Table of Contents

4

Dedicated to Ross Smith
whose original sketch inspired this project,
and to the many donors, artists,
business and community leaders
who brought it to fruition. (See page 102)

Tee Markers by Jerry Catania and Josh Andres

Graphic Design: Robin Maxon, Maxon Graphix
Orchestrated by Anne Odden
Photography: David Knight,
Don Ames and Anne Odden
Front and Back Cover: Nile Young
Written by Greg Ladewski

Published by:The Minot Publishing Company
280 Higman Park, Benton Harbor, MI 49022
www.waterstreetglassworks.org

Printed in the United States of America

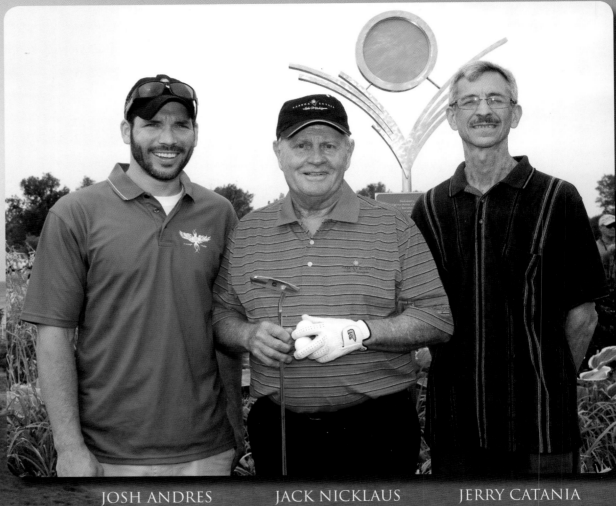

JOSH ANDRES JACK NICKLAUS JERRY CATANIA

introduction

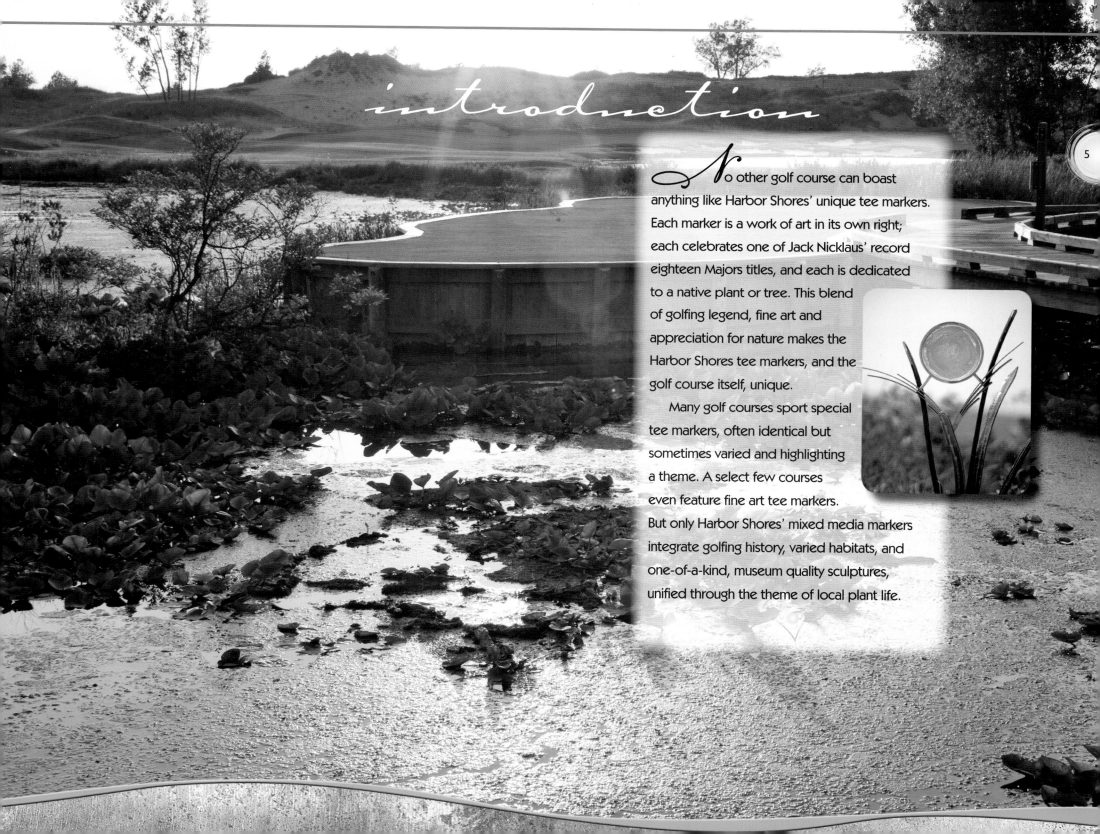

No other golf course can boast anything like Harbor Shores' unique tee markers. Each marker is a work of art in its own right; each celebrates one of Jack Nicklaus' record eighteen Majors titles, and each is dedicated to a native plant or tree. This blend of golfing legend, fine art and appreciation for nature makes the Harbor Shores tee markers, and the golf course itself, unique.

Many golf courses sport special tee markers, often identical but sometimes varied and highlighting a theme. A select few courses even feature fine art tee markers. But only Harbor Shores' mixed media markers integrate golfing history, varied habitats, and one-of-a-kind, museum quality sculptures, unified through the theme of local plant life.

The inception

Like so many great ideas, Harbor Shores' unique tee markers are partly the product of serendipity -- a sort of happy accident. Resident Golf Pro Ross Smith had been musing about a design for the tee markers, when Water Street Glassworks' board president, Anne Odden, stopped by to acquaint him with the glass and metal studio complex. Odden described Water Street's mission as "problem solving."

Indeed, Smith had a "problem," though a small one, to be solved. He needed a series of tee markers for the course, and was looking for something unique – something that would set the tee markers, and the course itself, apart from all others. Their brief chat bore fruit when Smith imagined the Harbor Shores icon, "Celebration" (AKA the "Happy Guy") cast in metal and glass by Water Street artists.

CELEBRATING A LOGO

Master glass blower Jerry Catania and noted metal artist Josh Andres were pleasantly surprised by the versatility and artistry of Harbor Shores' logo (officially named "Celebration"), which each marker would include.

"Many logos would have been too sterile, or stylized, or just plain too corporate to enhance the art," remarks Catania. *"We didn't want to compromise our work for the logo. But,"* he continues, *"this one is perfect. I understand it was drawn up on the fly, on a kitchen napkin. It's as good as any I've ever seen, no matter how much time was put into it."* In the end, says Andres, *"We were able to incorporate the logo in ways that actually enhance the sculptures."*

HARBOR SHORES

Lake Michigan

"Celebration," Harbor Shores' logo, (also affectionately known as the "Happy Guy,") has been likened to a bird flying above hills of waving grass, a sunrise (or sunset), or a person with arms upraised.

Both Jerry Catania and Josh Andres found the logo, with its organic curves and elegant ambiguity, well-suited for incorporation into each marker. "It looks good whichever way it's tilted," noted Andres. "It fits in perfectly with the nature theme, but is just abstract enough that people see in it what they want to

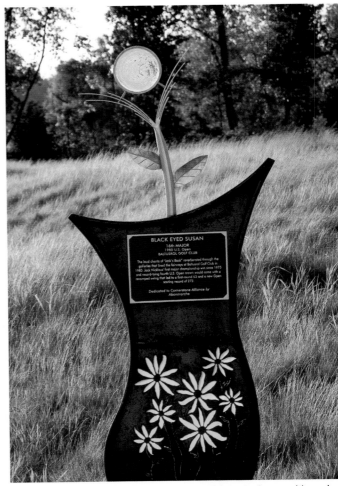

Perhaps "Celebration's" finest hour was when Andres positioned as if rising, a flower itself, from a bud vase at Hole 16 (Black-eyed Susan). In other markers, the logo might suggest a sun, a bird, a person in the background, or simply an ornament.

an even more ambitious project. They realized that fortuitously the eighteen holes of the course matched the legendary Nicklaus' eighteen Majors titles. Why not place a plaque on each tee marker, telling the story of a particular Nicklaus triumph?

Smith and the team took this thought a step further. Given the artists' virtuosity and the remarkable variety of natural settings on the course – from sand dunes to wetlands – the course could celebrate native plant life through the tee markers.

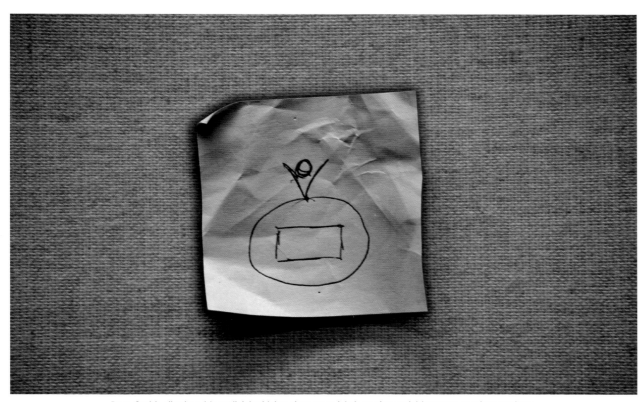

Ross Smith displays his scribbled idea that gave birth to the ambitious tee marker project.

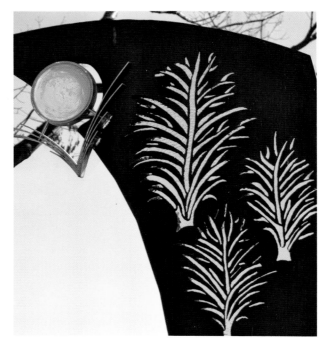

see." Far from a chore or an artistic compromise, incorporating the logo into the markers became an enjoyable challenge for the artists. "Finding the 'perfect' position for the logo was almost a game," laughs Andres.

On a Post-it note, Smith had scribbled a drawing of the logo rising out of a boulder.

But why stop there? A committee comprised of Smith, Developer Mark Hesemann and Harbor Shores Marketing Director Joen Brambilla envisioned

The Artists and the Art

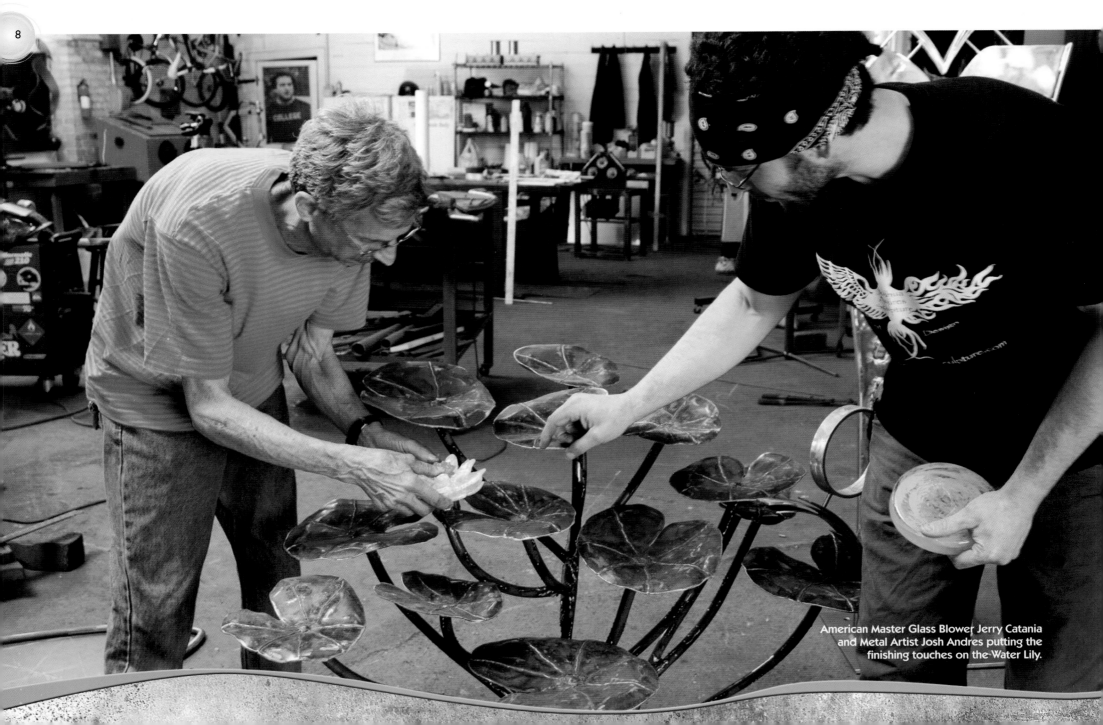

American Master Glass Blower Jerry Catania and Metal Artist Josh Andres putting the finishing touches on the Water Lily.

Prior to their intensive collaboration on the tee marker project, Jerry and Josh had never worked together. "I knew who he was, and I admired his work," said Jerry. Josh, who had previously worked mainly on his own, had recently become an instructor at the Blossom Fehlberg Metal Arts studio, an offshoot of Water Street Glassworks. Coincidentally, Andres' metal studio was located in the same building that had housed Jerry's father's mechanic shop. "I guess it was meant to be," Jerry muses.

The project, as first presented by Smith, Hesemann, and Brambilla to Catania and Andres, was very ambitious: to create eighteen glass-and-metal tee markers, each about five feet tall, representing different indigenous plants. More daunting still, the tee markers needed to be designed, approved, built and assembled in about three months, or just twelve weeks.

The deadline seemed impossible. "It can easily take that long to do a single commission," remarked Jerry. Also, the timing was "dicey." "When they

contacted me, I already had a full plate with my teaching duties," Jerry recalls. "I was building two new forges for the metal studio, and opening a Gelato shop. But," he adds, "This was a project I simply couldn't pass up." Andres, too, was busy, working on several commissions, and building his own house. However, unlike Catania, he was able to put these projects on hold, and could devote himself full-time to the tee marker project.

Jerry initially considered a simple template or model that would serve as the basis for each of the sculptures. He envisioned a "chalice" or "shield" pattern, a flat metal plate on a stand. The eighteen shields would have cutouts, into which molded, plate or blown glass plant forms would be inserted. Catania recalls: "My first thought was that only an assembly-line type process would allow us to finish eighteen sculptures within the deadline."

He and Josh quickly created a prototype, Cattail, about four feet tall, for the Harbor Shores arts committee.

This plant seemed the easiest to do

quickly, recalls Catania, who had no guarantee that the project would move forward. "We were operating on a handshake," he recalls. "We never really had a contract."

At the prototype's "unveiling," the arts committee was favorably impressed. Though Harbor Shore's Public Art Consultant, Susan Wilczak, was not excited by the stamped-out nature of the proposed works, the committee seemed ready to give the go-ahead for all eighteen works.

However, the ever-cautious Jerry had also brought a "Plan B," consisting of five pencil sketches. ("You never know what people will like," he says drily). These concept drawings did not follow the cut-out "shield" format, but depicted unique, stand-alone structures. When Jerry shyly offered these drawings, "I was blown away," recalls Smith. "Creating one-of-a-kind works of art took the project to a new level," Susan Wilczak, art consultant, adds approvingly. "That's what makes this course unique, from an artistic perspective."

The two artists had mixed feelings

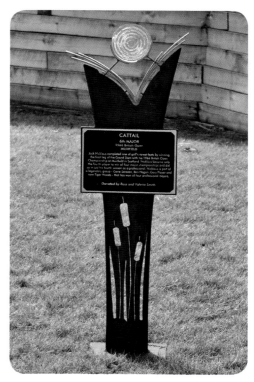

The artists' prototype sculpture of a Cattail employed the original "shield and cutout" form.

about the amplified assignment. Recalls Catania, "As a businessman, I preferred the cookie-cutter approach of the cutout shields. But as an artist, I was thrilled by the challenge of creating eighteen completely different sculptures."

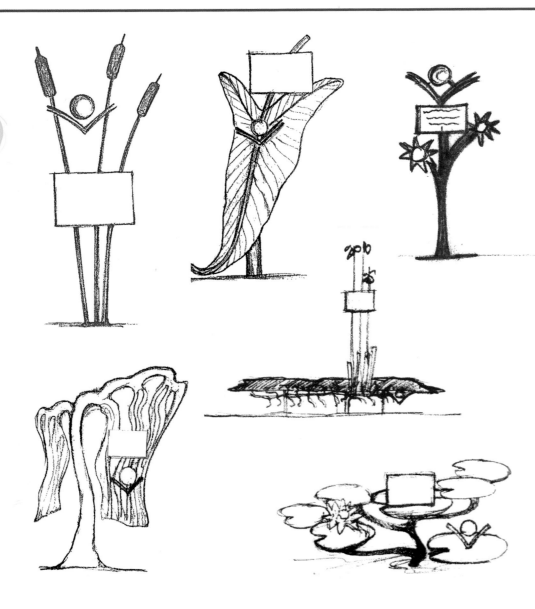

While recognizing the obvious difficulties, Andres was more confident. His most recent work had employed nature forms, including trees and bushes. This experience proved invaluable, though as Andres recalls, "I had to work at a brand new level, both in technique and efficiency. My subconscious must have been working like mad, because the ideas were just pouring out. I trusted my instincts and kept moving ahead. I had to, if we were going to fulfill our promise to Harbor Shores and keep our artistic integrity."

The Harbor Shores committee made two decisions: (1) Each sculpture would be individual and three-dimensional, designed for the specific hole, and (2) markers would be built on a grander scale: up to seven feet tall.

In the end, some of the finished sculptures employed an enhanced "shield-and-cutout" form, similar to Jerry's original concept. However, most are three dimensional "sculptures in the round." Whichever the design, all are one-of-a kind works of art.

Above: Offered as his "Plan B" to the Harbor Shores committee, Catania's five individualized sketches were selected over the more standardized "shield design" form. This meant that each marker would be unique, and large. It also meant that each work would need far more time for design and completion. The tight deadline for completion, however, did not change.

To the right: View of golf course taken from above Lake Michigan looking east towards Southwest Michigan's Regional Airport (aka Ross Field). Location of tee markers are indicated by number.

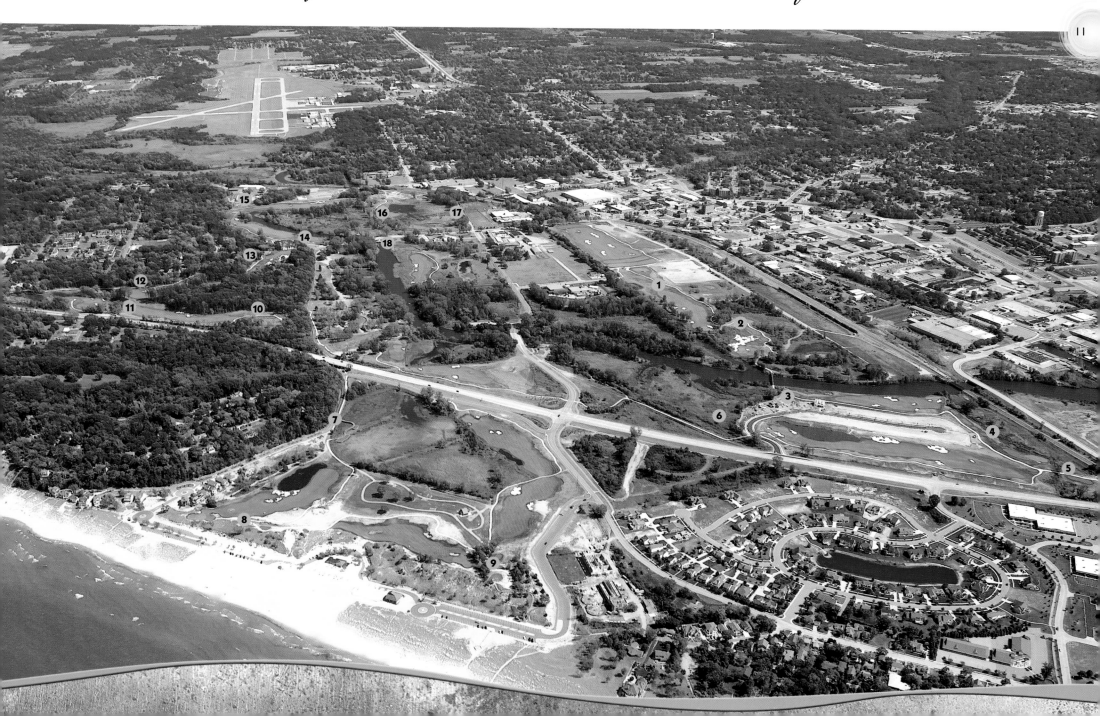

Location of Tee Markers on Golf Course

The Process

Starting with Catania's prototype design and concept drawings, the artists collaborated to create the eighteen individualized works. Once they agreed on the basic concept, Josh did the initial "heavy lifting," literally as well as metaphorically.

Andres had free rein to alter Catania's concepts "mechanically and proportionately" to meet his own artistic vision and to best accommodate the special qualities of glass and steel. For example, "Jerry's original cattail design was sparse -- just three stems," Andres recalls. He added interwoven strands of grass or reeds through the stalks at the base, as both an artistic and structural (support) element. "Josh improved my design ten times over," Catania admits.

Most sculptures were initially conceived and sketched by Catania and approved by Andres. From there, the process varied, according to the artists' schedules and the nature of the work.

Some markers "started with the steel," in Andres' words. An example is Hole 11 (Sugar Maple). Andres designed and built the textured metal trunk and branches, to which Catania added the spectacular glass

leaves afterward. Other works, such as Hole 1 (Aster) began when Catania handed over the large glass elements to Andres. Catania did not see the sculpture again until its completion.

At first, several Harbor Shores officials, especially Ross Smith, Hesemann and Brambilla, oversaw the work closely. Andres appreciated Hesemann's "very artistic eye." Smith recalls that he "practically lived in Josh's studio for a couple of weeks." Ross kept saying, "Bigger, bigger!" remembers Andres, smiling. "I liked that, because we metal artists like to work on a large scale." Joen Brambilla's catchword was 'More glass.'"

However, the Harbor Shores officials understood that the markers could not be designed or built "by committee." ("That would only guarantee that someone would be upset," Smith conceded.) Impressed by the consistently high quality of the work and respecting the cramped quarters Josh toiled in, the observers were less advisors than appreciative onlookers, privileged to see the creative process turn out one masterwork after another.

"It became very friendly," Andres recalls. "After the first couple markers, they stepped back and trusted us."

As one after another of the sculptures took shape, the artists enjoyed an increasingly free hand to design the markers as they saw fit. Jerry's poured-glass "Happy Guy" logos, initially limited to yellow only, began to show swirls of color or even glitter.

In the end, the hard and sometimes frantic work paid off. Against all odds, the artists completed and delivered all eighteen works on time, only twelve weeks after receiving the go-ahead from Harbor Shores.

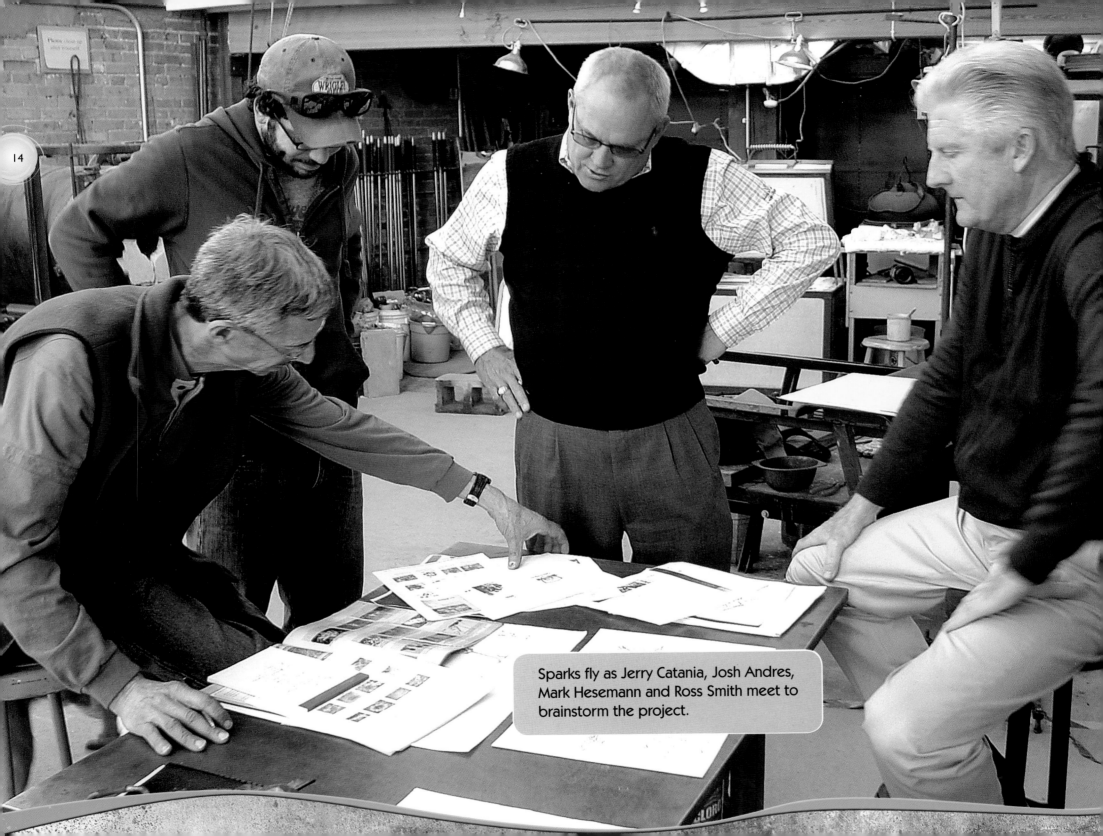

Sparks fly as Jerry Catania, Josh Andres, Mark Hesemann and Ross Smith meet to brainstorm the project.

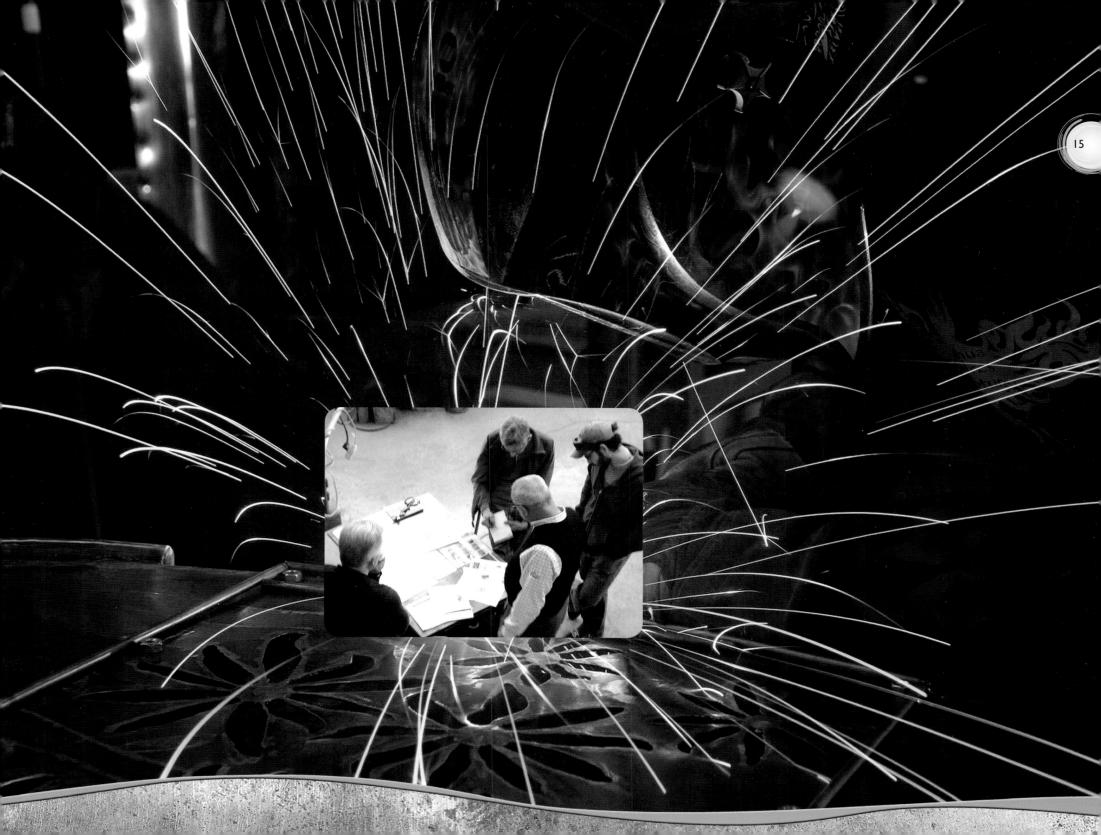

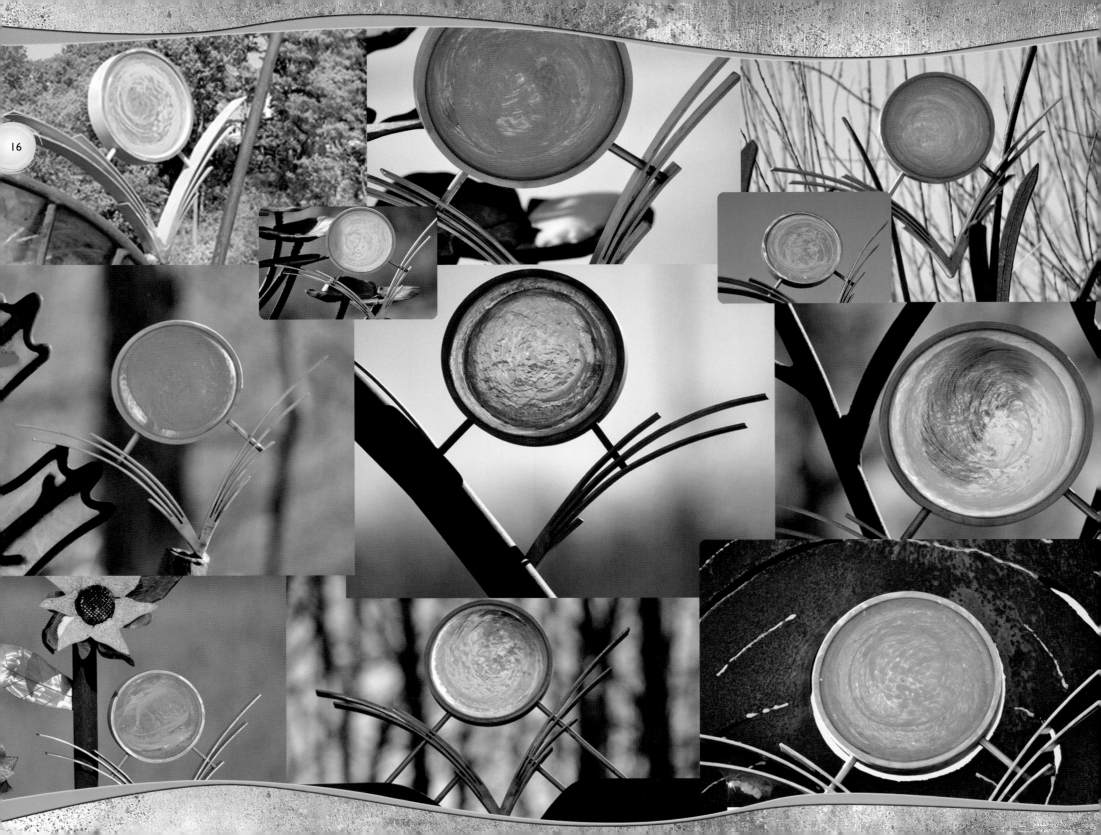

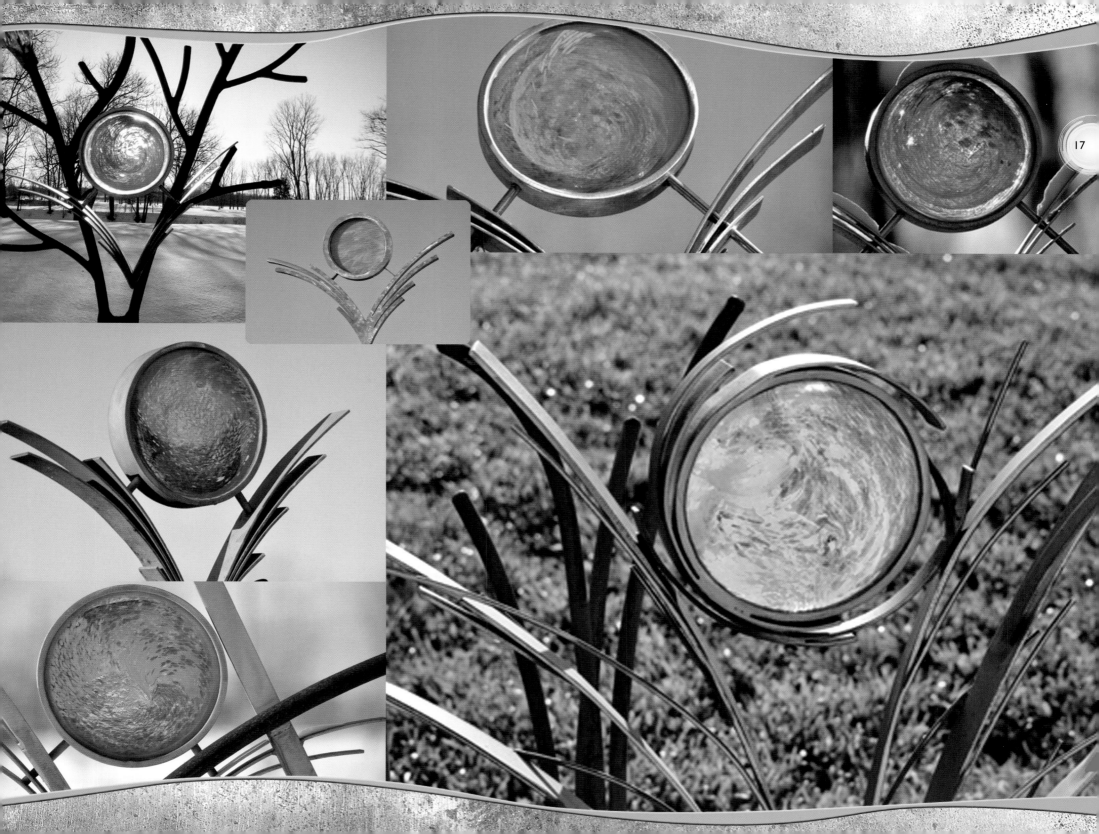

Representation versus Interpretation

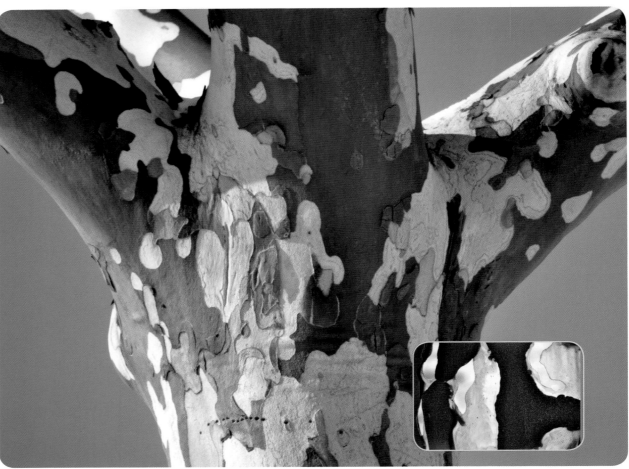

The artists insist that their work interprets, rather than represents, the subject plants. "A representation is literal, like a photograph or a botanical drawing," says Andres. "While I appreciate the craftsmanship involved, ultra-realism doesn't interest me very much as a metal artist. I'm looking for what's essential about the plant, and to put that forward, sometimes even at the expense of what's 'true to life.'" Catania agrees. "For each marker, I asked myself, 'What is this plant about'? A Sycamore tree is 'about' its bark. Sometimes I wanted to highlight a feature that could be overlooked. I love the aster's petals, but they're so tiny you almost need a magnifying glass to make them out. So I enlarged the flower a couple hundred times, and distilled each petal down to its essence. Now you can't help but see how remarkable the individual petals are."

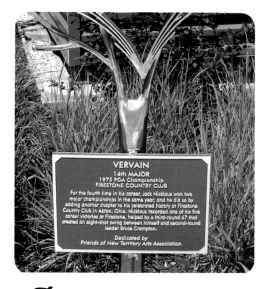

VERVAIN
14th MAJOR
1975 PGA Championship
FIRESTONE COUNTRY CLUB

For the fourth time in his career, Jack Nicklaus won two major championships in the same year, and he did so by adding another chapter to his celebrated history at Firestone Country Club in Akron, Ohio. Nicklaus recorded one of his five career victories at Firestone, helped by a third-round 67 that created an eight-shot swing between himself and second-round leader Bruce Crampton.

Dedicated by
Friends of New Territory Arts Association

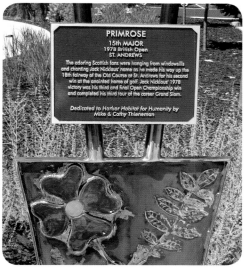

PRIMROSE
15th MAJOR
1978 British Open
ST. ANDREWS

The adoring Scottish fans were hanging from windowsills and chanting Jack Nicklaus' name as he made his way up the 18th fairway of the Old Course at St. Andrews for his second win at the anointed home of golf. Jack Nicklaus' 1978 victory was his third and final Open Championship win and completed his third tour of the career Grand Slam.

Dedicated to Harbor Habitat for Humanity by
Mike & Cathy Thieneman

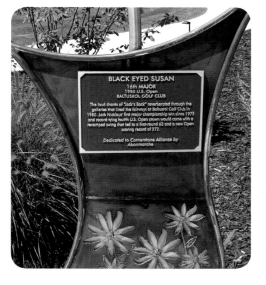

BLACK EYED SUSAN
16th MAJOR
1980 U.S. Open
BALTUSROL GOLF CLUB

The loud chants of "Jack's Back" reverberated through the galleries that lined the fairways at Baltusrol Golf Club in 1980. Jack Nicklaus' first major championship win since 1975 and record-tying fourth U.S. Open crown would come with a revamped swing that led to a first-round 63 and a new Open scoring record of 272.

Dedicated to Cornerstone Alliance by
Abonmarche

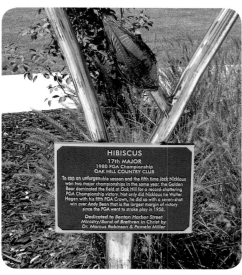

HIBISCUS
17th MAJOR
1980 PGA Championship
OAK HILL COUNTRY CLUB

To cap an unforgettable season and the fifth time Jack Nicklaus won two major championships in the same year, the Golden Bear dominated the field at Oak Hill for a record-shattering PGA Championship victory. Not only did Nicklaus tie Walter Hagen with his fifth PGA Crown, he did so with a seven-shot win over Andy Bean that is the largest margin of victory since the PGA went to stroke play in 1958.

Dedicated to Benton Harbor Street Ministry/Band of Brethren in Christ by
Dr. Marcus Robinson & Pamela Miller

Despite the artistic freedom they enjoyed, the artists had to work within three constraints, or required elements, for each marker. The first, and perhaps most difficult, was the plaque. In Jerry's words, "It's not always easy to place a rectangular shape on an organic form without detracting from the composition." Adding to the design problem, the large plaques had to be positioned to be readable from a golf cart.

Next, each marker prominently bears the "Celebration" (or "Happy Guy") logo. Because the logo itself is organic and abstract, this presented less of a challenge than the artists had first feared. Indeed, Jerry and Josh came to appreciate its versatility. "It looks good straight up-and-down or tilted at almost any angle," Andres says. "We actually had a lot of fun with it." As a result, no two markers have the logo in the same place or orientation.

When Catania got the go-ahead to add more colors to the basic yellow mix, the logos gained even more significance by complementing the other glass elements.

The third constraint was the tee markers' position on the course. Each sculpture must be placed close to the tee, positioned to stand out without distracting the golfer. The final placement should balance the artistic concept with the practical purpose of the marker.

In addition to these requirements of the commission, the artists deliberately chose to work with a "limited vocabulary" of only three materials: Corten metal, stainless steel and glass. "No one told us to stick with these three elements," recalls Catania. "But this was a useful sort of discipline, and also helped keep things simple. Different as they are, the finished sculptures have an overall unity that a wider palette or variety of materials might have missed." Josh Andres chose two contrasting metals: Corten metal and stainless steel. By design, Corten rusts on the outside, and then is "self-sealing." "Mature" Corten develops a velvety russet brown patina that matches the color of the steel golf course bridges. It is also ideal for textured organic forms such as the cattail heads and acorn tops.

Catania, who was less familiar with Corten, admits he was a bit skeptical at first. "I didn't see much difference between the stainless steel and the still-unfinished, shiny Corten. But when the Corten darkened, it created the kind of contrast we were looking for," he remembers. In the end, Jerry was "much happier with the Corten than I ever imagined." (Josh, of course, never had any doubts!)

The other metal Josh chose, stainless steel, is ideal for the surgical-clean lines of the cattail leaves, the mirrored Arrow Arum leaf and the crisp, curving lines of the Rose Pink stems.

Some say the two contrasting metals have a symbolic dimension. The Corten represents Berrien County's "rust belt" past; the stainless steel its shiny future.

A unique setting in

By a happy accident of geography, Berrien County, including Harbor Shores, is a naturalists' dream: the most ecologically diverse county in Michigan - indeed, it is the most varied setting within hundreds of miles.

"Berrien County didn't know what kind of ecosystem it wanted to be," according to Ecologist Brian Majka. "So it's a little bit of everything, mashed together." Blessed by a temperate microclimate created by prevailing westerly winds and the proximity to Lake Michigan, Berrien County boasts some of the richest soil in the world, and acre for acre, the most diverse farm produce in the Midwest. The diversity of its natural plant life is, if anything, even more impressive.

Here, northern wildflowers and trees such as the Hemlock have their southernmost outposts, and southern species their northern boundaries. Here Michigan's southernmost true bogs "butt up" against arid sand dunes (sometimes complete with prickly pear cactus). Here, so-called "disjunct species" improbably meet: eastern plants "cheating" to the west, such as the New England Aster of Hole 1, mingle with Black-Eyed Susan and other western prairie flowers "cheating" eastward.

Set in Benton Harbor, Michigan, the Harbor Shores Golf Course is, in effect, a microcosm of this microcosm.

The Harbor Shores Golf Course was carefully situated to span at least four distinct habitats.

As the golfer plays through, he or she begins in a prairie setting with asters, rose pink and blackeyed susans (Holes 1 – 3). Dry land transitions to wetlands, home to water lilies, bulrushes, cattails and arrow arrum (Holes 4-7).

Once again, the golfing landscape changes abruptly. From the tee at Hole 7, situated on a boardwalk over a pond, the player drives toward the inviting white sands of Jean Klock Park. The dune holes, offering a majestic vista of Lake Michigan, are considered the crown jewel of the course. Here, the sculptures celebrate the dune grass and blue stem grass (Holes 8-9).

Moving off of the white sands, the golfer's experience is, once again, suddenly and completely different: woods. (Holes 10-13). Here is the "dance of the climax giants," Red Oak and Sugar Maple, followed by fragrant Sassafras and spreading Sycamore.

The remaining five holes (14-18) are essentially "wetland" or "moist upland" holes, but each is completely different in character.

Several of the holes span two or more different zones. Hole 5, for example, begins in a prairie and ends at the river!

Hole 1

(New England) Aster

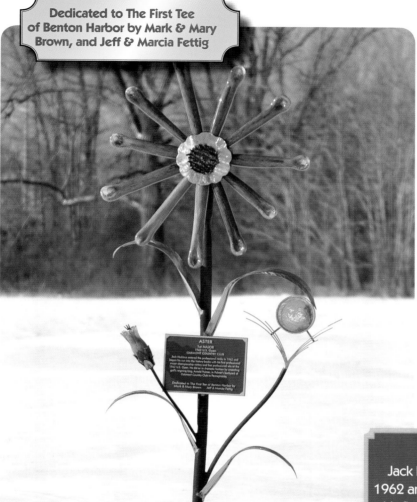

Dedicated to The First Tee of Benton Harbor by Mark & Mary Brown, and Jeff & Marcia Fettig

Scientific Name: Symphyotrichum novae-angliae

The spectacular Aster at Hole 1 is a stunning introduction to the seventeen markers that follow. Viewing the seven foot sculpture up close is like seeing the delicate, tiny flower through a microscope. Glass predominates, as the petals' intense, translucent purples "pop out" against the duller browns of the Corten steel stem.

True to the New England Aster after which the marker is patterned, the petals are narrow at the base and fan out toward the tips. In fact, each "petal" is a flower (and eventually, a seed) in its own right, a detail evident in Catania's interpretation.

1962 U.S. Open - 1st Major

Jack Nicklaus entered the professional ranks in 1962 and began his run into the history books with his first professional major championship victory and first professional win at 1962 U.S. Open. He did so in a dramatic fashion by unseating golf's reigning king, Arnold Palmer, in Palmer's backyard at Oakmount Country Club in Pennsylvania.

The Aster, a "ray flower," reflects the star pattern for which it is named. The artists highlighted the intricacy and importance of each petal-flower by spacing them out, rather than clumping them together. The resulting, stylized Aster bloom has a deceptively simple, almost naïve quality. "Ask a child to draw a flower," Catania remarks. "Chances are you'll get something like this. I wanted the first tee marker to have this most basic form."

Phoenix Clark, 3rd Grade

Golfers and other viewers may be surprised at the glass elements of the sculptures. Outdoor art is usually metal, marble or concrete, materials expected to weather the elements. Viewers may wonder

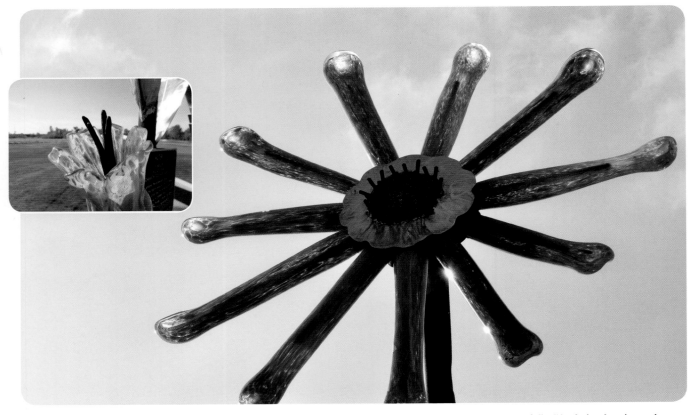

Catania made the complex purple petals "as big as I could make them in one pour." He adds somewhat ruefully, "Scale in glass is much harder than scale in metal. Josh could have made the sculptures as massive as he wanted, if it weren't for the practical limit on glass size."

The Aster was sacred to Venus, goddess of the Morning Star. Thoreau wrote, "Why so many … asters now? The … stars have shone on the earth, and the asters are their fruit." Thoreau, Journal, August, 1853.

at the apparent fragility of the aster's petals, especially where they narrow at the flower's base. In fact, glass is remarkably durable; the tee markers should easily withstand both summer's heat and winters' deep freeze.

Jerry Catania's concept drawing emphasized the aster's star-like, archetypal form. He then created the eleven purple petals "as large as I could make them." He dropped them off at Josh's studio and left for a two-week teaching assignment. "It was a mystery to me

what Josh would make of it," he recalls. When I finally saw the finished work, I was tickled."

Andres tried different heights and stem sizes before he found the right proportion. "It had to be so big you can't miss it," he said. "I wanted people to have to look up at it. This is the beginning of the course, and this tee marker needed to make a statement that art and nature are as important to the Harbor Shores' experience as the tees and greens."

Ironically, the lovely New England Aster, given pride of place at Hole 1, is related to the dandelion, that bane of homeowners and groundskeepers. In fact, with over 150 varieties, the aster family is one of the most prolific, highly evolved and successful plants.

Seemingly delicate, the New England Aster is actually quite hardy and adaptable -- good traits for golfers as well as flowers.

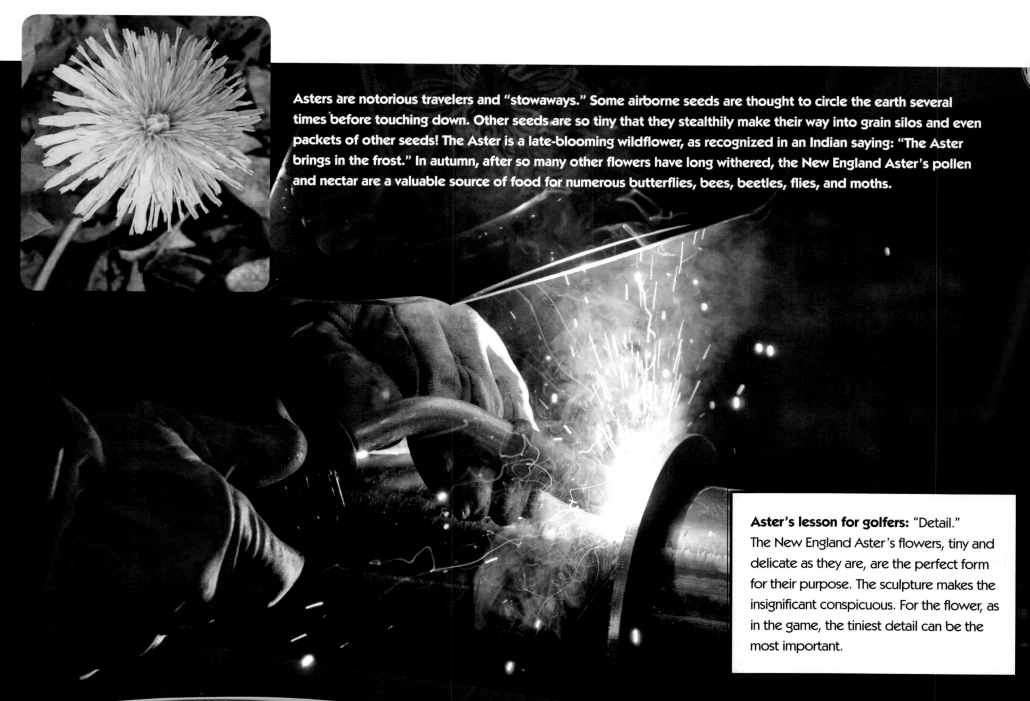

Asters are notorious travelers and "stowaways." Some airborne seeds are thought to circle the earth several times before touching down. Other seeds are so tiny that they stealthily make their way into grain silos and even packets of other seeds! The Aster is a late-blooming wildflower, as recognized in an Indian saying: "The Aster brings in the frost." In autumn, after so many other flowers have long withered, the New England Aster's pollen and nectar are a valuable source of food for numerous butterflies, bees, beetles, flies, and moths.

Aster's lesson for golfers: "Detail."
The New England Aster's flowers, tiny and delicate as they are, are the perfect form for their purpose. The sculpture makes the insignificant conspicuous. For the flower, as in the game, the tiniest detail can be the most important.

Rose Pink

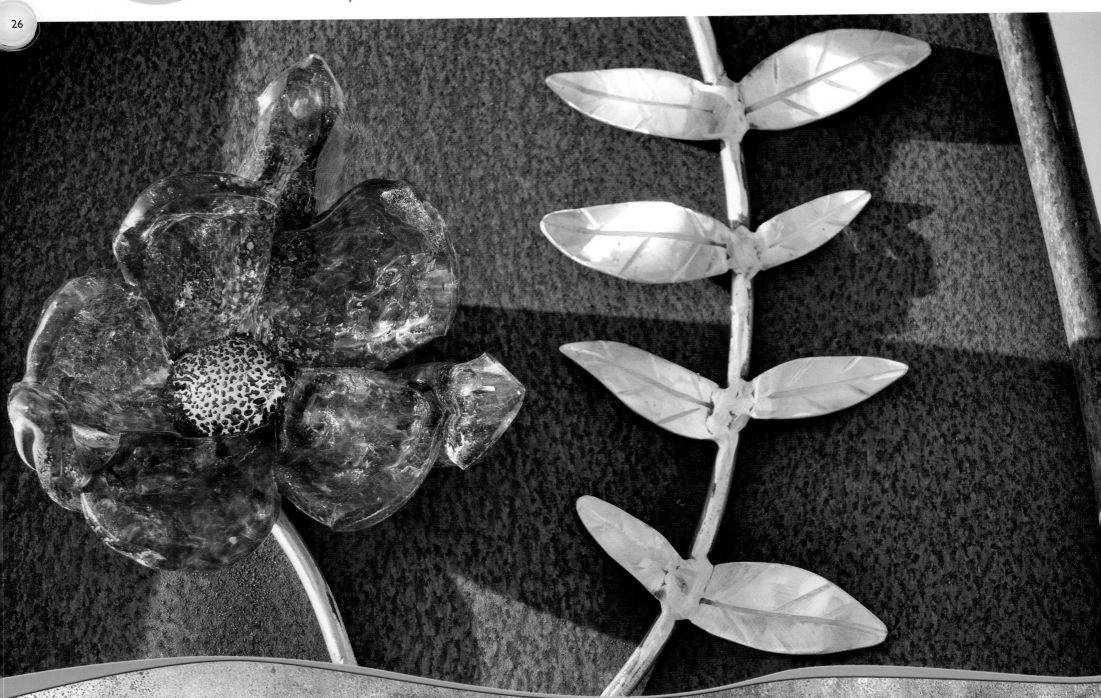

**Dedicated to
Hospice at Home by
Smith-Dahmar Associates**

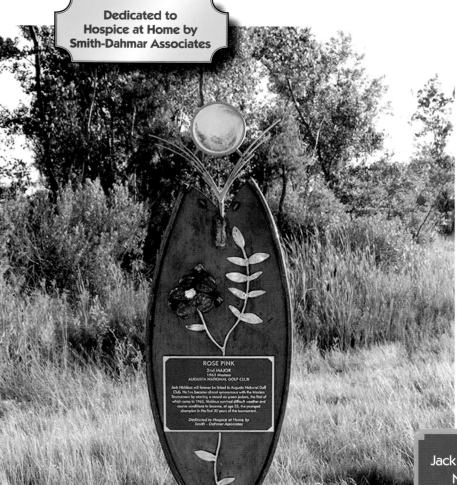

Scientific Name: Sabatia angularis
Common Names: Rose Pink, Marsh Pink,
Bitterbloom

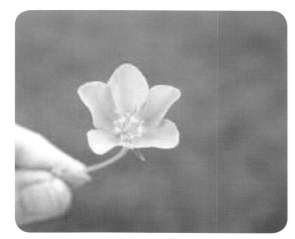

Legend says that when Eve was expelled from Eden, she took one flower, a rose, as a reminder of the Garden's beauty. Originally white, one legend says the rose turned pink when it pricked Eve's finger as she carried it away. Another says that it blushed pink for shame.

This rare flower's essence is captured in the deep, varied red glass petals and the elegantly woven metal vines and stems. Flowers and stem are set against a cutout metal shape that suggests a bud vase. The Celebration logo, swirling yellows and reds, rises proudly from the top of the vase, like another flower.

1963 Masters - 2nd Major

Jack Nicklaus will forever be linked to the Augusta National Golf Club. He has become almost synomous with the Masters Tournament by winning a record six green jackets, the first of which came in 1963. Nicklaus survived difficult weather and course conditions to become, at age 23, the youngest champion in the first
30 years of the tournament.

The Rose Pink is legally protected as a designated "state threatened" plant. Resist any temptation to take a "souvenir" home! Even to break off a leaf is an illegal "taking" that could carry a hefty fine. Most Rose Pinks on the course are inside roped-off "protected areas." However, some are found along the paths and hillsides.

ENVIRONMENTALLY
SENSITIVE
AREA

ENTERING THIS AREA
IS PROHIBITED

PLEASE NOTE LOCAL RULE

To a Wild Rose

Four characteristic pieces for piano
Edward MacDowell

"To A Wild Rose"
E. MacDowell, Lyrics H. Hagedon

Come, oh, songs! come, oh, dreams!
Soft the gates of day close,
Sleep, my birds, sleep, streams!
Sleep, my wild rose!

The Rose Pink marker uses the "shield" model that was originally planned for all the sculptures. Catania's luscious, dark pink flower is pressed into the solid shield, rather than backlit or free-standing. The glass bloom is subdued instead of flashy, and best seen when viewed close-up — rather like the flower it honors. The Celebration logo, rather than the rose flower, rises from the vase-shaped shield.

O my Luve's like
a red, red rose
That's newly sprung
in June
O my Luve's like
the melodie
That's sweetly played
in tune
(Robert Burns)

"Wild Irish Rose"

My Wild Irish Rose,
The Sweetest flower that grows.
You may search everywhere
But none compare with my wild Irish Rose.

My Wild Rose,
The dearest flower that grows.
And someday for my sake,
She may let me take.
The bloom from my wild Irish rose.

The Grimm Brothers' folk tale, Snow White and Rose Red, has been a favorite for generations.

Because Rose Pink has a short blooming season, the designers planted numerous other pink flowers, such as Queen of the Prairie, in and around this hole, so that golfers could enjoy the delicate pastels at any time.

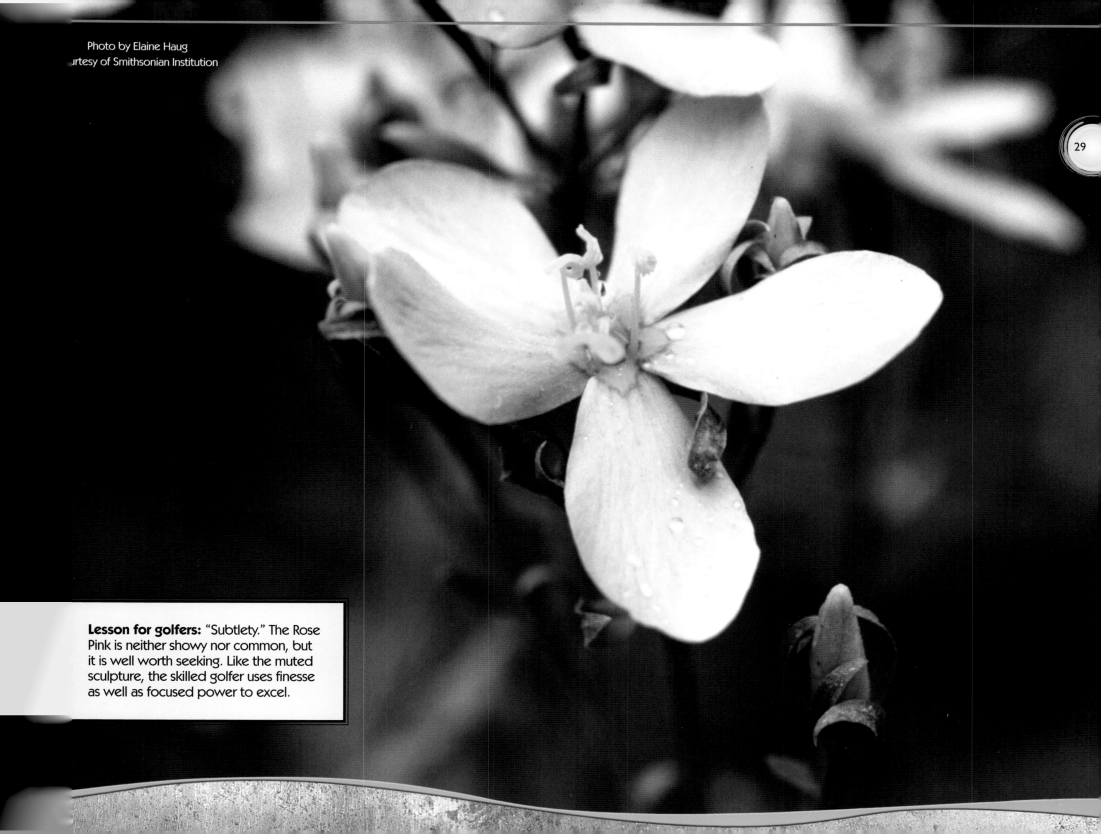

Photo by Elaine Haug
urtesy of Smithsonian Institution

Lesson for golfers: "Subtlety." The Rose
Pink is neither showy nor common, but
it is well worth seeking. Like the muted
sculpture, the skilled golfer uses finesse
as well as focused power to excel.

Sunflower

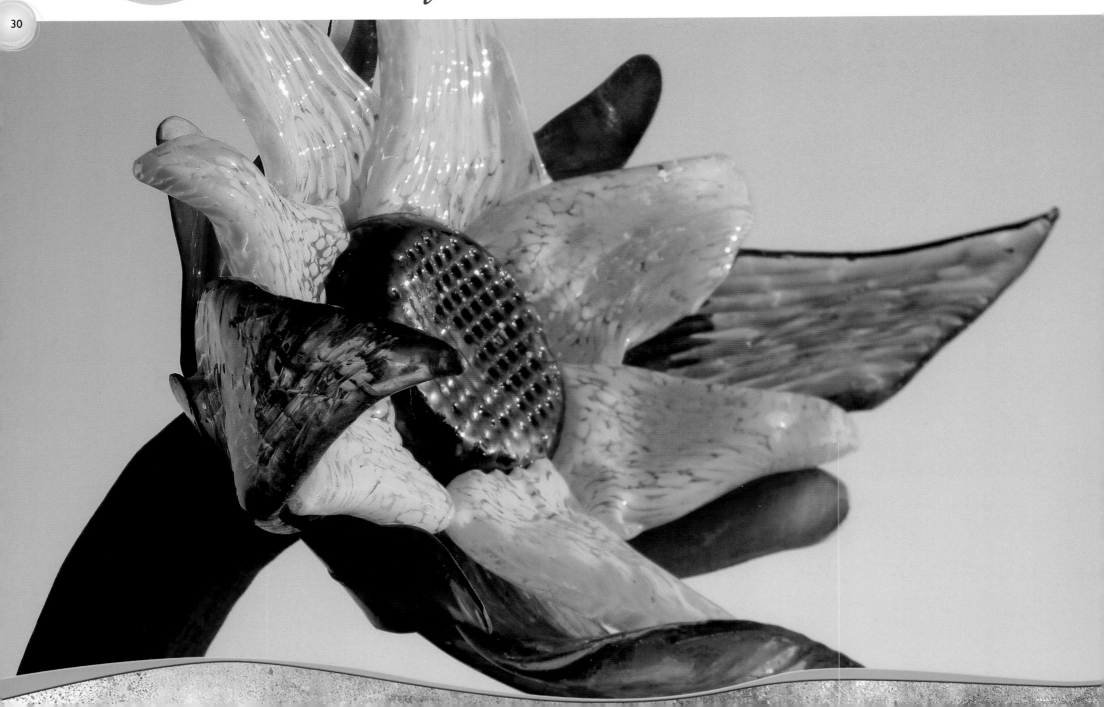

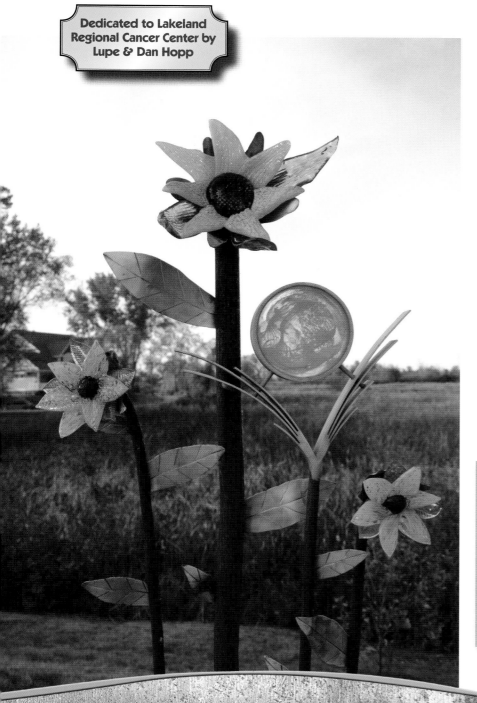

Dedicated to Lakeland Regional Cancer Center by Lupe & Dan Hopp

Scientific Name: *Helianthus annuus*

The artists chose a true native, the common sunflower with its star-shaped leaves. (The more familiar, massive, round-headed sunflowers sold at farmers' markets are actually hybrids from Russia).

Every sunflower is a masterpiece of architectural strength. Able to grow up to a foot in one day, the stalk, which can reach five feet tall or higher, must hold up the plant's heavy, seed-crammed head. The sculpture highlights this paradox by making the Corten stalk disproportionately thick compared to the as-yet immature flower.

Native Americans and pioneers prized the Sunflower for its usefulness as well as

its beauty. Its seeds, food for bird and beast alike, produce a valuable cooking oil. Dried, they make a tolerable coffee substitute. Its yellow flowers make delectable honey and a vivid dye. Sunflower stalks can be made into strong textiles and even paper; the leaves, which make nutritious animal fodder, have been dried and smoked like tobacco. To this day the sunflower remains an important commercial crop in Michigan.

1963 PGA Championship - 3rd Major

In less than two years as a professional, Jack Nicklaus grabbed the third leg of golf's coveted Grand Glam when he won the 1963 PGA Championship at Dallas Athletic Club. The Golden Bear not only survived a talented field but survived temperatures that soared over 100 degrees. It was so hot that Nicklaus had to hold the championship trophy with a towel.

courtesy of Kathy Allen

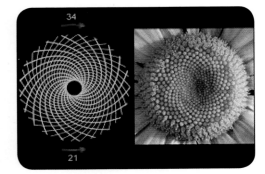

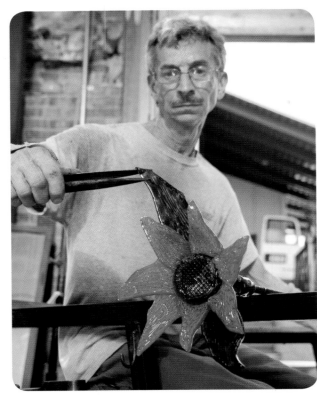

*T*he whorls of the sunflower seeds illustrate the "Fibonocci Series." This mathematical formula creates a spiral form often found in nature, such as pine cones, nautilus shells and even our own galaxy.

Like the Aster (Hole 1), Black-eyed Susan (Hole 16) and the dandelion, the Sunflower is a "Ray Flower," highly evolved and complex. A Sunflower head can have 1000 seeds, and weigh several pounds — mostly oil.

Native to America, the sunflower was quickly exported to, and embraced by, the Old World. The most commercially successful sunflowers were cultivated in Russia and Turkey. Sunflowers were a favorite subject of Vincent Van Gogh and Gustav Klimpt.

According to Greek mythology, the Sunflower honors Clytie, a nymph who fell madly in love with Apollo, the sun god. Apollo spurned her love, and she wasted away, her eyes always fixed upon the sun. To this day, the Sunflower always keeps it head turned toward the sun, and symbolizes adoration.

"The sunflower turns on her god when he sets
The same look which she turned when he rose."
— Thomas Moore

Sunflower's lesson for golfers:
"Dedication." The Sunflower follows the sun's course with a single-minded intensity sometimes likened to adoration. The resulting plant is not only striking, but among the most productive and useful of any native flower. Golfers would do well to take a lesson from the passion and perseverance of the Sunflower.

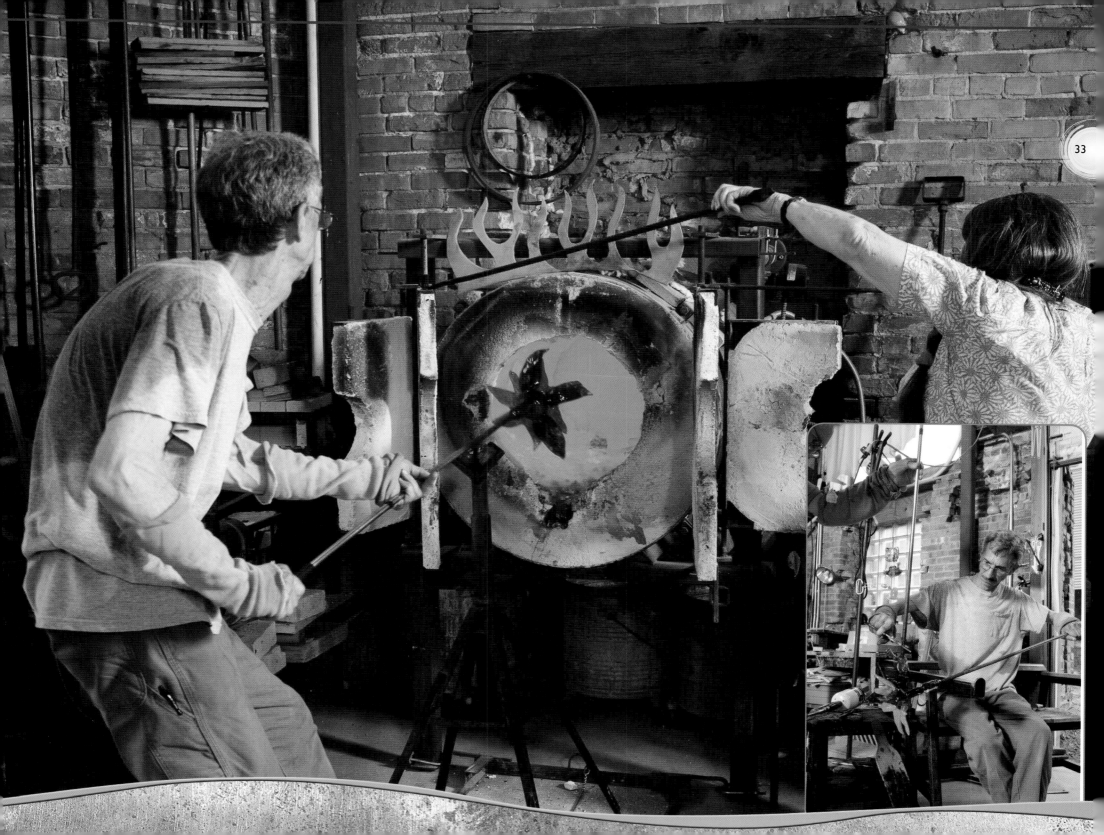

Water Lily

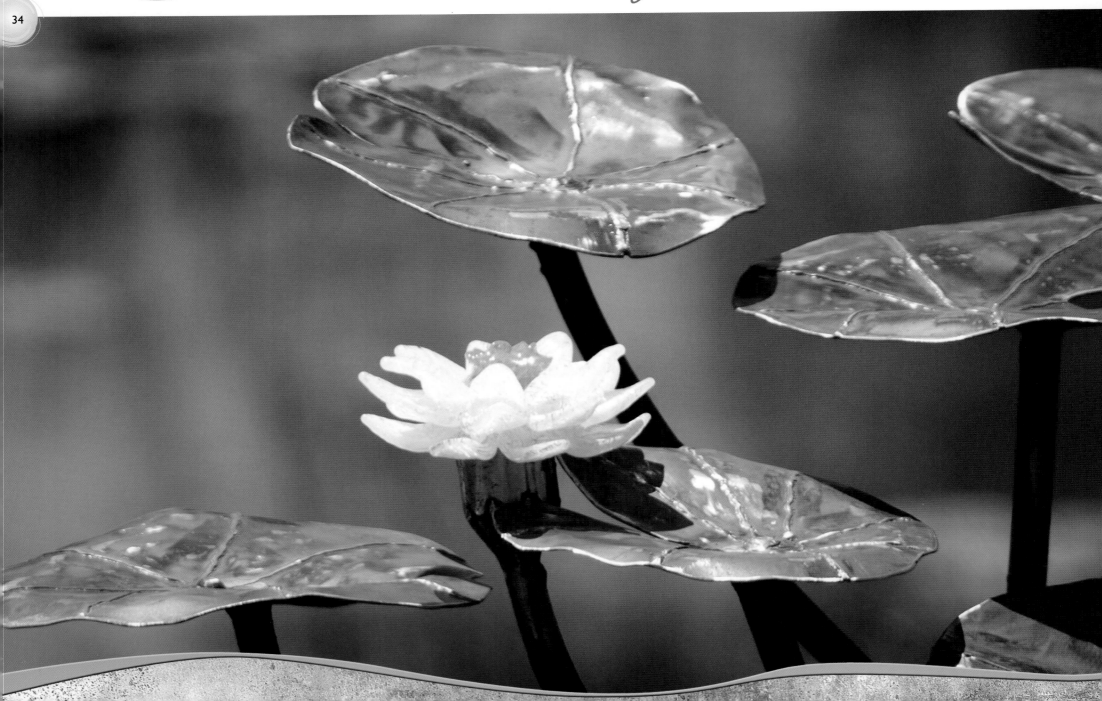

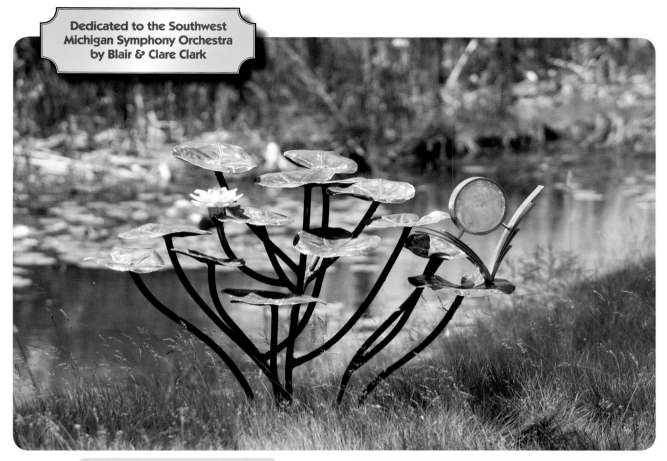

Dedicated to the Southwest Michigan Symphony Orchestra by Blair & Clare Clark

water by the placement of the leaves. The water lily's stems and leaves thrust upward to the single, yellow and white glass flower that establishes the "surface."

Water Lily becomes a cascading fountain in the rain, as water fills the hollows in the sculpted leaves and trickles down. The single white and yellow flower suggests springtime.

Most markers put their "best face forward" for approaching golf carts. The Water Lily is an exception, equally attractive from any vantage. It is well worth the time to pause and admire this work of art close up.

> "I have a faint recollection of pleasure derived from smoking dried [water] lily stems before I was a man. I …. have never smoked anything more noxious. I used to amuse myself with making the yellow drooping stamens rise and fall by blowing through the pores of the long stem."
> Thoreau, Journal, June 26, 1852.

1965 - Masters 4th Major

Jack Nicklaus and Arnold Palmer traded green jackets for the third year in a row, as Nicklaus dominated the field and humbled Augusta National with a record-setting victory. Nicklaus' 17-under-par finish broke Ben Hogan's record by two, and his nine-shot victory over Palmer set a new standard. The Golden Bear's third-round 64 tied Lloyd Mangrum's 25-year-old course record.

Scientific Name: Nymphaea Odorata
(meaning - "Fragrant water lily")

Unlike the upright "stem-and-flower" works at other holes, the Water Lily marker is oriented horizontally. Andres' goal was to create the illusion of a plant immersed in the water – to capture the "feel" of

A Native American myth said that the water lily was a star that fell into the water.

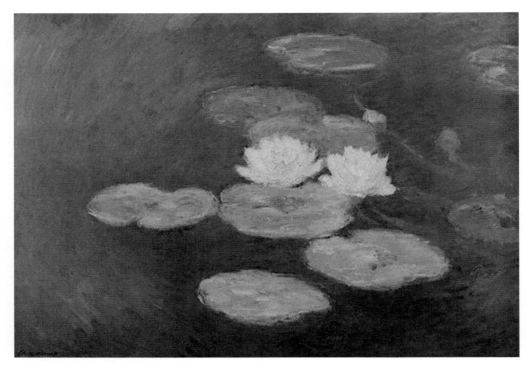

The water lily has always been a favorite subject for artists, especially Impressionist Claude Monet, who created dozens of pictures featuring the water lily at his chateau in Arles.

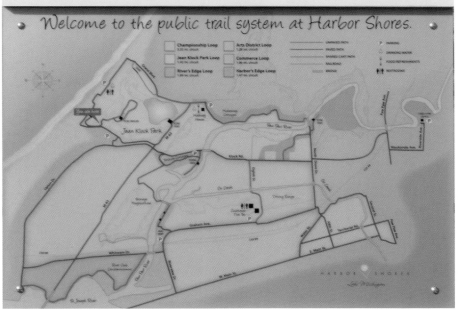

Welcome to the public trail system at Harbor Shores.

Tee Markers as Public Art

"Museum art" is meant to be viewed carefully, at leisure. Even so, studies show that the typical gallery visitor spends at most ten to twenty seconds on a painting or sculpture.

Golfers are even less likely to linger over the tee sculptures, as they must focus on their own game, and avoid creating a bottleneck for other players. Thus, the tee markers were designed so they could be taken in at a glance, says Public Art Consultant Wilczak. Even so, "you can't help notice them as you speed by," she adds, "and this has to add to the experience, even 'subliminally.'"

Art enthusiasts who sign up for tours or who travel the nature trails that crisscross the course will find that these works are well worth leisurely contemplation.

Water Lily's lesson for golfers: "Multi-Dimensionality." The Water Lily "dwells" in three worlds: its roots probe the earth beneath the pond; its stems are underwater, and its flowers and leaves break the surface to the open air. A good golfer, too, is multi-dimensional, tailoring equipment, technique and strategy to master green, rough and trap; to adapt to changing wind and weather, or any other factor encountered.

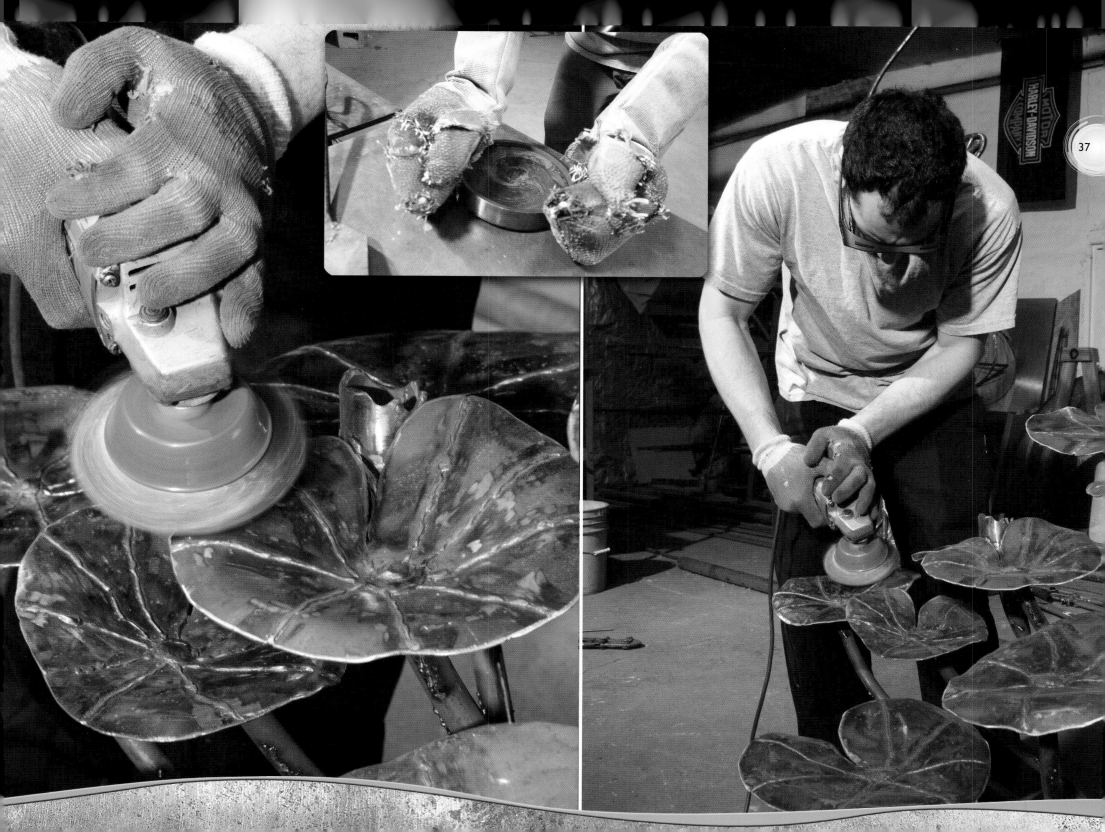

Bulrush

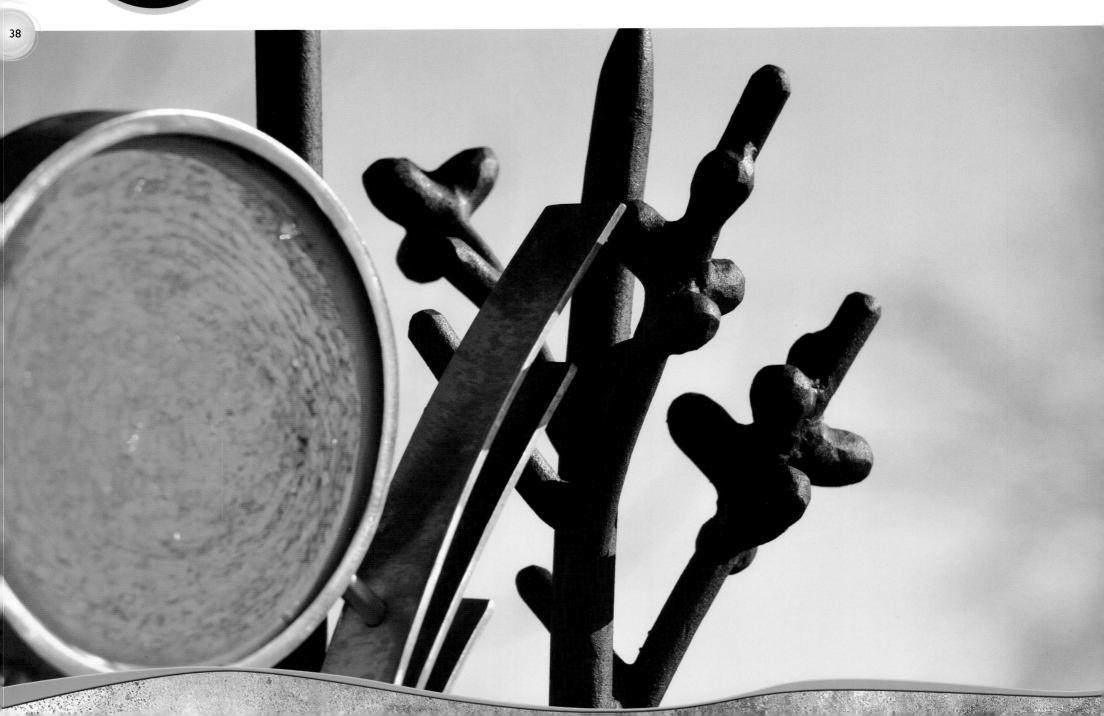

Scientific Name: Schoenoplectus pungens

Nature is seldom obvious. Often, the most important plants and animals are inconspicuous, drab and easily overlooked. One of four markers whose only glass element is the Celebration logo, Hole 5's Bulrush unabashedly celebrates the plant's spiky and decidedly un-showy structure, as well as its resilient strength.

Golfers will appreciate the relative scarcity of insect pests on the course. They should thank, at least in part, the lowly bulrush, duly honored in Josh Andes' striking, minimalist sculpture.

Easily overlooked and certainly unappreciated, the "workhorse" bulrush is essential to the health of the Harbor Shores wetlands and to the comfort and enjoyment of the golfers. Dragonflies and damselflies, voracious mosquito-eaters, thrive on the bulrush stems and tops. The plant's intricate root system provides cover for fish fry, tadpoles and frogs, which also feed largely on mosquito larvae.

1966 Masters - 5th Major

Jack Nicklaus became the first back-to-back winner in Masters Tournament history, winning his third green jacket in four years with his 1966 victory at August National. This win would not come until Nicklaus survived 17 lead changes and an 18-hole playoff with Gay Brewer and Tommy Jacobs.

Joshua Andres - Metal
Jerry Catania - Glass

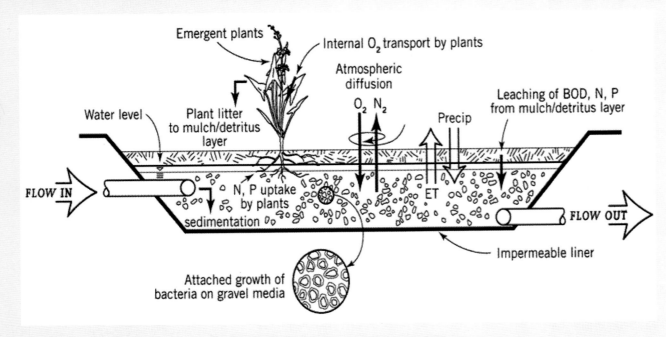

Emergent plants

Internal O₂ transport by plants

Atmospheric diffusion

O_2 N_2

Precip

Leaching of BOD, N, P from mulch/detritus layer

Water level

Plant litter to mulch/detritus layer

FLOW IN

N, P uptake by plants

sedimentation

ET

FLOW OUT

Impermeable liner

Attached growth of bacteria on gravel media

Contrary to popular belief, wetlands – at least, healthy wetlands – are not breeding grounds for mosquitoes. Sedges such as the bulrush provide breeding areas and cover for small fish, tadpoles and other beneficial creatures who feast on mosquito larvae. These plants also filter out excess nutrients (preventing alga blooms) and even remove heavy metals and other toxins through their root systems.

"Bulrush" Kate Seidel, PhD

More than 60 years ago, Dr. Seidel made an astonishing discovery. Wetland plants, principally the bulrush, but also cattails, arrow arum and other reeds, do not merely survive in polluted water. They thrive, and in the process, return the befouled water to a safe, even drinkable state.

Her studies, and extensive municipal projects using her patented system, proved that the bulrush is in essence a living water-treatment facility. (One test facility, operating in winter, attained wastewater quality "not previously held possible.")

Bulrushes exude antibiotics that kill harmful viruses and bacteria (like E. coli and salmonella) but spare beneficial bacteria. Bulrushes destroy mould fungi and worm eggs. Harmful substances, including tar and road runoff, excess fertilizer, asbestos, and even heavy metals (including cobalt, nickel and manganese), are filtered and removed from the water, sometimes at an astonishing rate.

Perhaps most remarkably, bulrushes quickly absorb radioactive materials, releasing it into the air in a gradual, and safe, rate. "Our plant cultures took up radioactivity and later there was no trace of it," noted Dr. Seidel.

Lauded as deserving the Nobel Prize for her lifelong work with wetland plants, Dr. Seidel died without receiving the honors that were her due. Perhaps chemical and civil engineers, familiar only with complex equipment and exotic chemical processes, felt threatened or insulted that a botanist – and a woman at that – proposed solving the problem of clean water with something as low-tech as the mundane, lowly bulrush.

"Bulrush Kate's" legacy, is the promise of cheap, clean water through plants.

The bulrush, one of the few plants that "likes to get its feet wet" (can grow in standing water) is found throughout the golf course's "water holes." (Its Hebrew name, used in the Biblical story of Moses, literally means "absorbs water.") Along with other water-loving plants, the bulrush thus helps mitigate flooding.

Once nearly crowded out by invasive water species, bulrushes again thrive in their original habitat, thanks to extensive rehabilitation of the Harbor Shores wetlands. The "chairmaker's rush" and the three-square bulrush, with its unique triangular stem, were also re-introduced to the area.

In Egypt, the Bulrush was used to make papyrus, an early, and very durable, sort of paper. With their strong, long fibers, bulrushes and other reeds provided Native Americans and settlers an ideal material for making ropes, mats, netting and baskets.

With the water lily (Hole 4) and cattail (Hole 6), the bulrush is a "successionary" plant, part of Mother Nature's long-term plan to turn lakes to marshes, and marshes to prairies. "Nature doesn't like standing water," says Sarett Nature Center's Director, Chuck Nelson. "Ponds become marshes, marshes become moist lowlands, and lowlands become meadow or even dry prairie." All of these habitats are found on the Harbor Shores course.

The choice of the bulrush for Hole 5 had artists and Harbor Shores executives scratching their heads. "My first thought was 'With all these trees and showy flowers, why in the world choose the bulrush?" recalls Jerry Catania. "I mean, it's basically a prickerbush." Course Manager Ross Smith admits "This was the one sculpture I was worried about. Bulrushes seem kind of, well, 'blah.'"

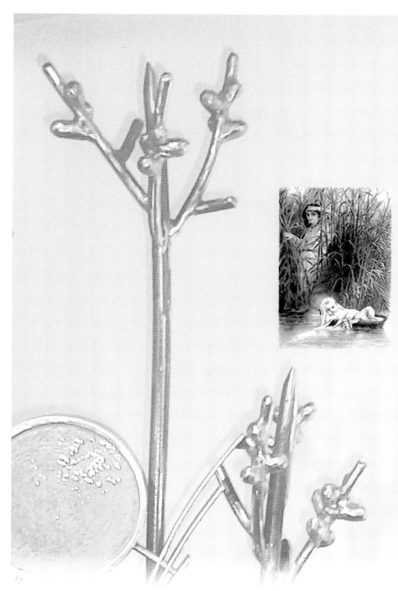

Josh Andres grasped the nettle (so to speak) by celebrating the bulrush's unapologetic straight lines and prickly personality. Smith, Catania, and especially the naturalists heartily approve of his unorthodox, but fitting, interpretation.

Most people have heard of the bulrush, if at all, through a Bible story. In Exodus, the infant Moses was placed in a basket of woven bulrushes and set adrift down the Nile River. Pharaoh's daughter saw the babe in the floating ark among the reeds and rescued him. Mark Twain's Huckleberry Finn mentions "Moses and the Bulrushers" as the first Bible story he ever heard, noting that at first he was "all in a sweat" to learn about it (presumably because bulrushes are common on the Mississippi), but lost interest when he learned that Moses was long dead.

Bulrush's lesson for golfers: "Homely virtue." The spiky, forbidding, seemingly unremarkable bulrush is one of the most important plants on the entire course, helping control both pests and pollution. Its reeds made a boat for the infant Moses, and chairs for American colonists. Golfers may wish to consider the unsung heroes and indispensible, but easy-to-forget tips and tools that can enrich their game.

Cattail

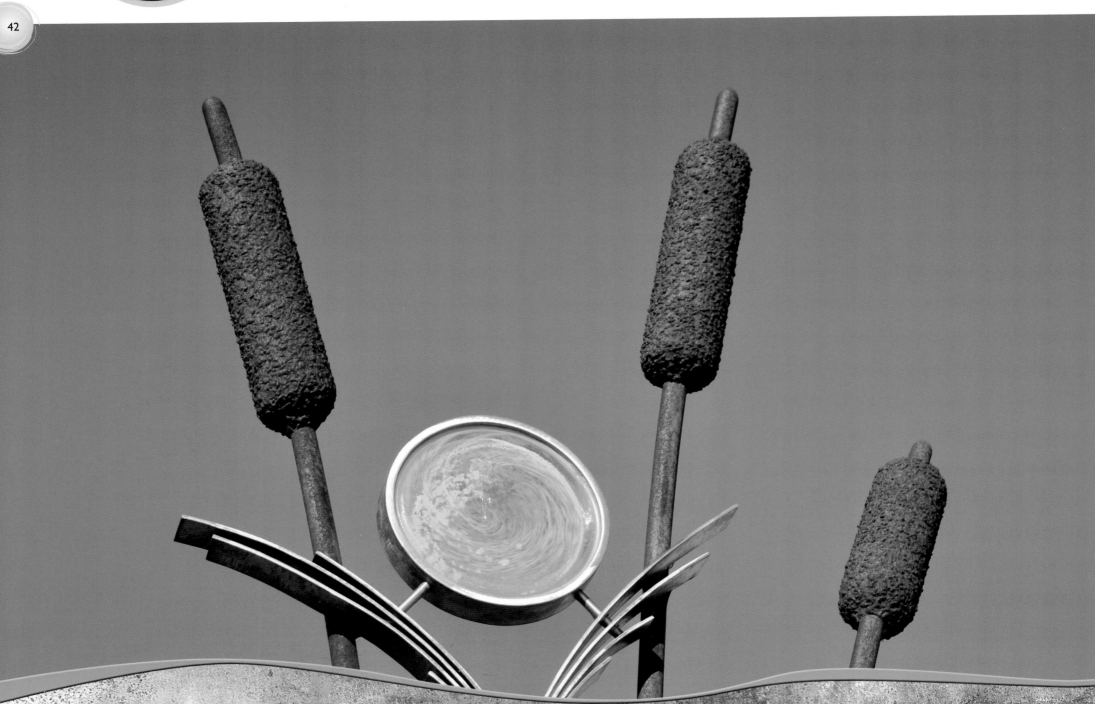

in the Wetlands

Dedicated to Evergreen Development by Bill & Joen Brambilla

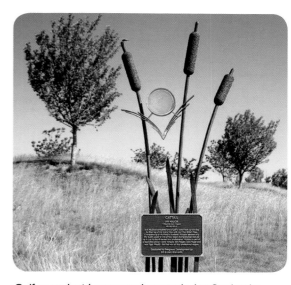

Golfers and art lovers may be puzzled at first by the Cattail sculpture at the tee for Hole 6: cattails are nowhere to be seen! The payoff comes at the end of this long hole, where cattails abound.

Scientific Name: Typha latifolia L.

The tall Cattail that marks Hole 6 is one of the most realistic sculptures on the course, and one of metal artist Josh Andres' personal favorites. There are three cattails because "we both like to work in threes," he says. Andres modified Catania's sparse sketch by adding interwoven grasses or rushes near the base, both as a design and structural (strengthening) element.

Corten is an ideal material for this sculpture, mimicking the color of the mature seed head (sometimes called a "catkin") and perfectly molded to capture its bumpy texture.

1966 British Open - 6th Major

Jack Nicklaus completed one of the golf's rarest feats by winning the final leg of the Grand Slam with his 1966 British Open Championship at Muirfield in Scotland. Nicklaus became only the fourth player to win all four major championships and did so in just his fourth season as a professional. Nicklaus is part of a legendary group - Gene Sarazen, Ben Hogan, Gary Player and now Tiger Woods - who has won all four professional majors.

Jerry's 3-D concept drawing (without grasses at base). Andres' addition of interlacing grasses at the base of the sculpture fills the design in artistically, and adds support to the sculpture.

A Plant For All Seasons

"*T*he supermarket of the swamp" was naturalist Euell Gibbon's description of the cattail. When green, the head can be boiled and eaten like corn on the cob. Its peeled stem is a nutritious food, and the jelly between its leaves reputedly has antiseptic properties. The plentiful yellow pollen of the cattail's head makes delicious flour for bread and pancakes. Combining cattail pollen and tubers with ingredients from the Arrow Arum and Water Lily yields a tasty, nutritious, all-natural cake: (Courtesy of Chuck Nelson)

Cattail Pollen Pancakes

1 cup cattail pollen
1 cup arrow arum or other flour
1 tsp salt
2 tsp baking powder
2 eggs
½ cup honey
¼ cup oil
2 cups milk
Mix dry ingredients together in a bowl. Add eggs, honey, oil, milk and mix thoroughly. If the batter seems too thick to pour, add more milk. Cook on a hot griddle until golden brown.

Cattail Wild-Rice Soup

2 cups cattail shoots, sliced (about 30 cattails)
1 cup dry wild rice (yields 4 cups)
2 Tbsp sesame oil
½ cup chopped green onion
2 tsp salt
4 cups chicken broth or other broth of choice.
Cook the wild rice until tender. In a heavy-bottomed soup pot, sauté onion and cattail shoots in sesame oil until tender and translucent. Add the cooked wild rice, salt and 4 cups broth.
Simmer together for 15-20 minutes and serve.

But for Native Americans' advice, early European settlers, ignorant of the cattail's secret treasure, could have starved, literally in the midst of plenty.

The cattail's nutritional value is not its only virtue. Native Americans dipped the mature catkin in oil and lit it for long-burning torches. Colonists stuffed their boots with cattail down for winter insulation. In World War Two (with the shortage of imported kapok), cattail down was among the native plant products used in flotation vests.

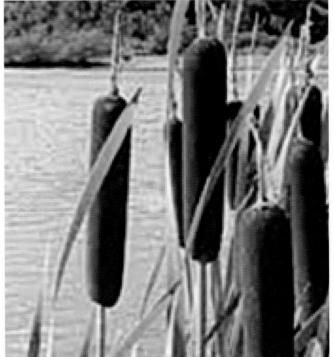

Cattails are easy to grow, and are a common feature of backyard artificial ponds. In fact, cattails can become a nuisance if left unchecked. They are allotropic, meaning that they produce chemicals that inhibit the growth of competing vegetation. Moreover, their thick root systems can crowd out other plants. Careful management checks cattails' proliferation, while keeping out invasive species.

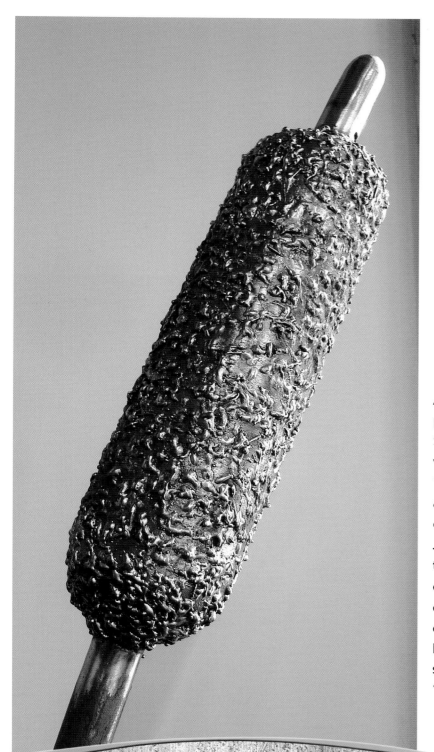

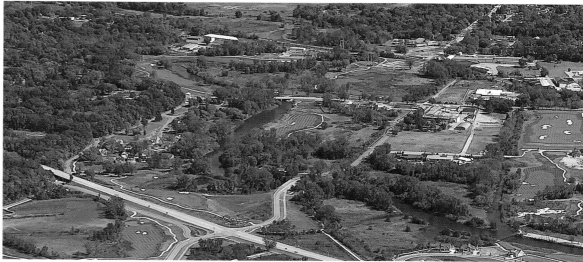

Hole 6 typifies the wide range and close proximity of the course's many ecosystems. Starting in prairie, the hole ends in a wetland. The happy proximity of dry, moist, and wet habitats was one factor that intrigued Jack Nicklaus and course developers, and led to the decision to build a Signature golf course in Benton Harbor.

A "shield" version of the Cattail was the artists' prototype that was presented to the Harbor Shores Arts committee. (See page 43). "This was an easy form for a cutout," says Catania, "but I thought it was too complicated for a structural treatment because of all the different parts. Once we got the commission, Josh had a better idea." Andres saw that the cattail was well-suited for a more three-dimensional approach. The lifelike Corten catkins are among the most striking metal elements in the tee marker series. The spear-like leaves are sharply defined in stainless steel, and Andres' intricate root system "grounds" the work.

Cattail's lesson for golfers: "Bounty." This "supermarket of the swamp" helped sustain Indians and pioneers who took the trouble to understand its many uses. As flour, as a vegetable, as a torch, and even as insulation, the cattail is a boon to man, beast and habitat. The cattail offers advice to golfers: you have everything you need, close at hand, if you only know where to look.

Arrow Arum

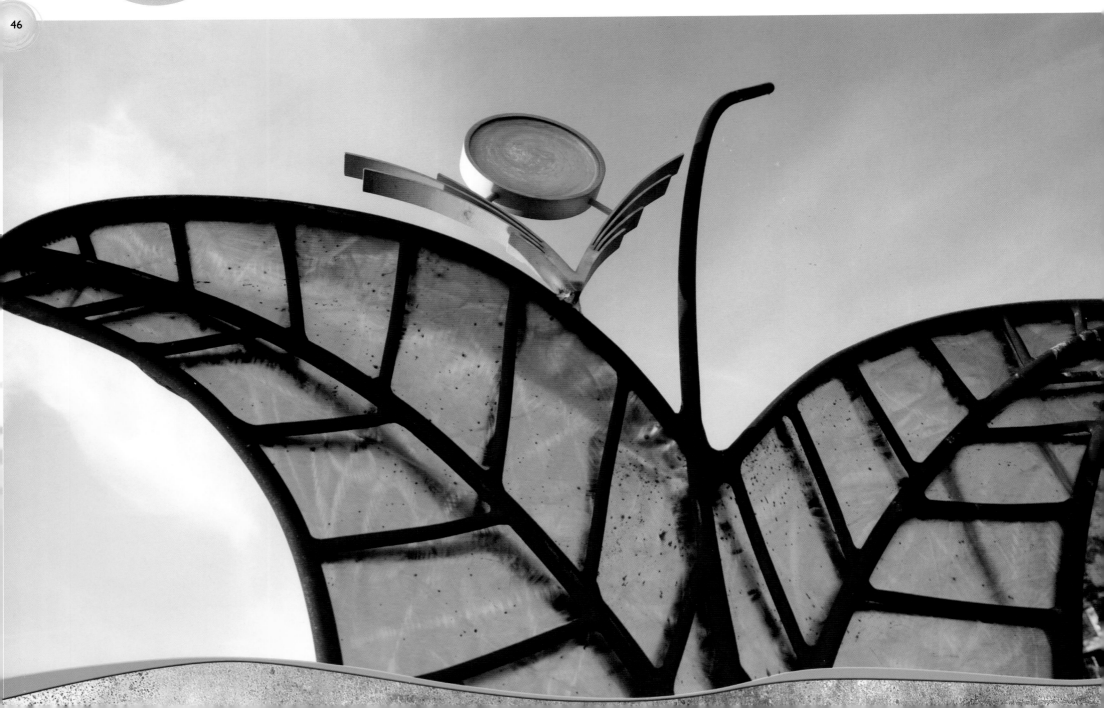

in the Sand Dunes

**Dedicated to
Berrien Community Foundation
by Bob & Anne Gottlieb**

Scientific Name: Peltranda virginica

"That's just wild."
A sightseer's critique.

Arrow Arum, Vervain and Aster are examples of sculptures that make the tiny gigantic. Andres is emphatic that "a six foot sculpture of a two inch plant is NOT simply a matter of 'blowing it up.' Some details must be emphasized and some omitted when you change scale drastically in one direction or another."

The Arrow Arum sculpture, in plain sight on a boardwalk near a public road, is probably the most viewed, and most talked-about, tee marker. It is also the most abstract design, rivaled only by Weeping Willow (Hole 18).

The artists zeroed in on the plant's most notable feature, its arrowhead-shaped leaf. But unlike the realism of the Water Lily, with its life-sized leaves, the Arum's tiny leaf is expanded a hundredfold and, for good measure, balanced on its pointed tip.

The result is wonderfully evocative, and open to interpretation. With the shiny, nearly mirrored stainless steel crisscrossed by bold Corten veins, it is impossible to miss, even from the road. Though comprised of a single leaf and stem, the sculpture has wonderful "movement," thanks to the graceful curves of the upside-down leaf's edge, and the enfolding of the sculpture itself. Here, perhaps more than any other work, the man-made quality of stainless steel is pitted against the organic texture of the ochre Corten.

From a distance, people have seen it as a butterfly, a bat, a heart, the Celebration logo, or even a knight's shield. You wouldn't know what it's meant to be until you see the caption. But as soon as you know, it makes perfect sense.

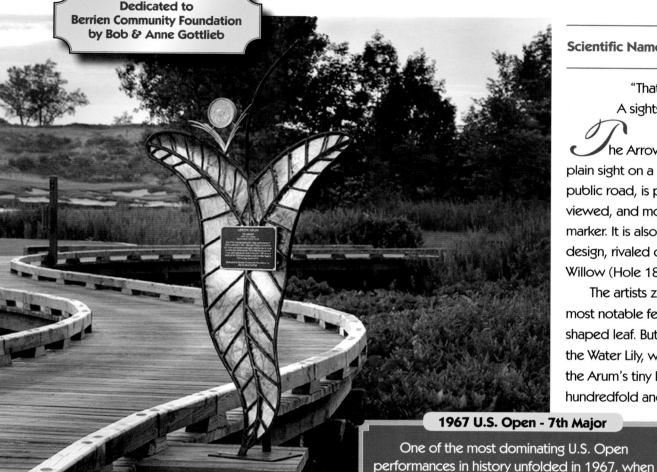

1967 U.S. Open - 7th Major

One of the most dominating U.S. Open performances in history unfolded in 1967, when Jack Nicklaus lowered the U.S. Open scoring record and again raised the bar for major championship performances. The Golden Bear's powerful 1-iron uphill and into the wind on the par-5 18th set up a birdie on the 72nd hole to break by one shot Ben Hogan's 1948 scoring record of 276.

The dense root systems of wetlands plants such as the Arrow Arum, cattail and bulrush operate as flood- and pest control agents, and provide cover for game fish minnows and other fry.

\mathcal{A}rrow Arum, just off the boardwalk, was originally intended to be placed in the pond itself. When the Michigan Department of Natural Resources vetoed this plan, the designers created a special stand for this unique sculpture. "It would have been wonderful in the water," says Smith, "but this way more people can see it from the road."

The original concept employed only the dark Corten veins. Josh used a "heat and beat" method to shape the open latticework of ¾ and ½ inch metal rods. "I liked the idea of being able to see the natural setting through the piece," says Catania. But Andres was not satisfied with the skeletal lattice, concerned that the dark form would not be visible in dim light or at a distance. He painstakingly hammered and bent 14 gauge stainless steel plating to the lattice's exact size and shape. He then welded the two elements together, giving the marker mass and depth. Andres toiled at least twenty five hours on the sculpture, not counting time spent on the design or the placement of the logo.

Called "Tuckahoe" by Native Americans, the Arrow Arum has edible tubers, and berries favored by ducks. Its flower, or spadex, is "an ugly fellow," notes naturalist Brian Majka. The Arrow Arum prefers shallow water, and helps clean up streams and ponds by filtering out both excess nutrients (such as fertilizer) and toxins.

Hole 7 is another example of the abrupt changes in settings on the course. The tee, located next to a pond, is surrounded by "the finest wetlands on the course." (Brian Majka). The cup is squarely in the arid dunes.

What's in a name?

Given the diversity of plant life on the course, the selection of only eighteen plants required some difficult choices. One candidate that made the "short list" was Milkweed. "With its big pod and fluffy seeds, Milkweed would have been a fun project," remarked Andres. What knocked Milkweed out of the running was its name ("-weed") and associations: some people consider it a nuisance, with its poisonous, sticky, milky sap.

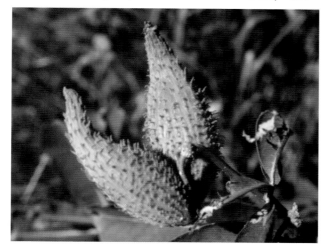

For obvious reasons, other worthy plants with even more unfortunate names, such as skunk cabbage, sneezeweed, stinkweed and spiderwort, didn't make even the first cut.

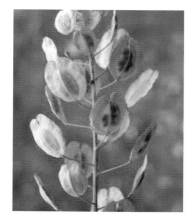

Stinkweed and Milkweed are examples of names which could not be celebrated.

Right: Josh Andres installs sculpture on site and visible from the road.

Arrow Arum's lesson to golfers: "Perspective." The Arrow Arum marker, a titanic leaf balanced on its very tip, is hard to interpret at first. Upon seeing the title, the puzzled viewer has an "aha" moment, as a new perspective, and a new meaning, emerge. The golfer, too, has his or her "aha" moments, when the mysterious suddenly becomes clear, and the seemingly unattainable possible.

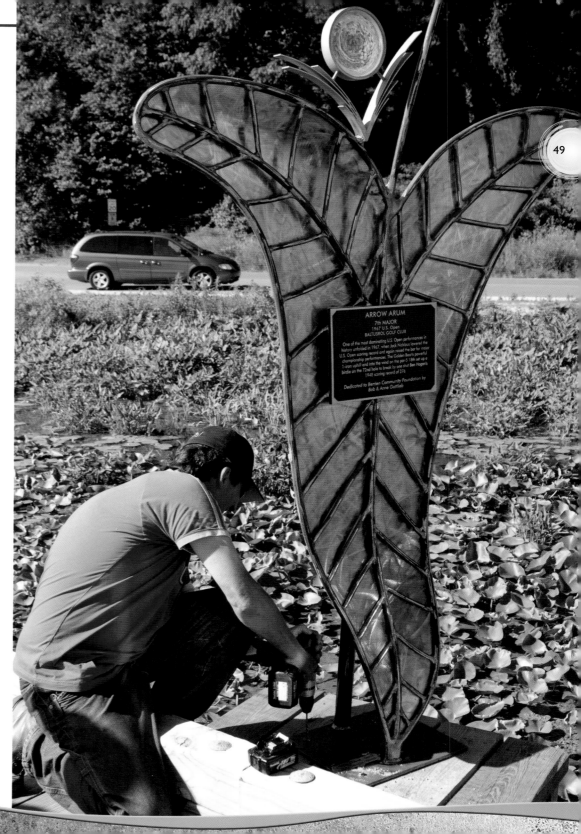

Dune Grass

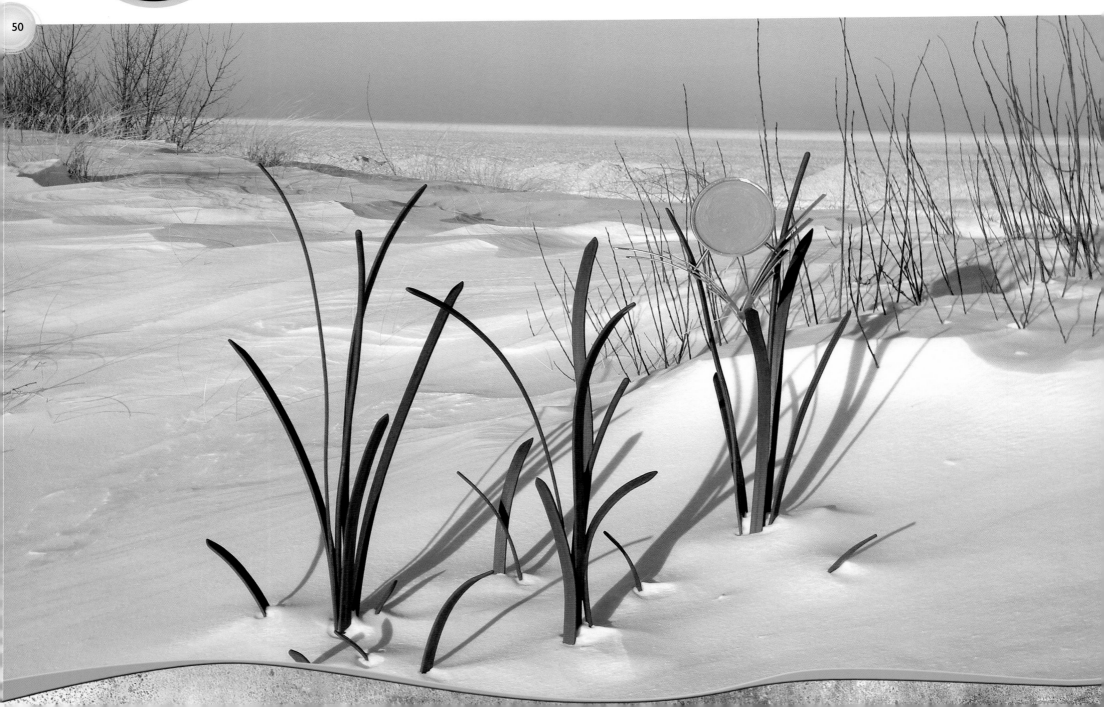

in the Sand Dunes

**Dedicated to
St. Joseph Public Schools Foundation
by Bill & Jane Marohn**

Scientific Name: Ammophila Poaceae
(meaning: "Moving sand")
Common Name: Beach or Marram Grass

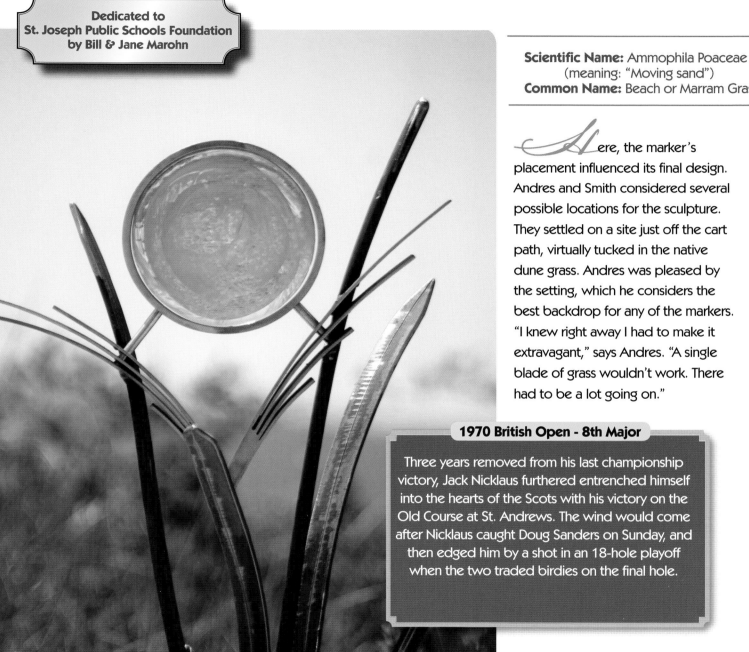

Here, the marker's placement influenced its final design. Andres and Smith considered several possible locations for the sculpture. They settled on a site just off the cart path, virtually tucked in the native dune grass. Andres was pleased by the setting, which he considers the best backdrop for any of the markers. "I knew right away I had to make it extravagant," says Andres. "A single blade of grass wouldn't work. There had to be a lot going on."

On the other hand, there was no feasible way to represent mature dune grass, which "makes its statement with expansive seas of sweeping grass." (Brian Majka) Andres compromised by depicting several "plugs" of grass – rather like the grass plugs planted by landscape rehabilitators from JFNew in the dune restoration project. Andres' steel root systems "ground" the sculpture, and enhance its realism.

The finished sculpture is "busy," with stalks bent and overlapping in every direction to create the illusion of movement in a breeze. Andres even welded beach sand into his Dune Grass sculpture, for texture and for symbolism. "Josh did an amazing job of creating such a compelling work based on a plant that has no color, no flower or buds," marvels Catania.

Seen in the distance, Lake Michigan reflects the seasons, freezing into snowball mountains in the winter, thawing into a refreshing dip in the summer.

1970 British Open - 8th Major

Three years removed from his last championship victory, Jack Nicklaus furthered entrenched himself into the hearts of the Scots with his victory on the Old Course at St. Andrews. The wind would come after Nicklaus caught Doug Sanders on Sunday, and then edged him by a shot in an 18-hole playoff when the two traded birdies on the final hole.

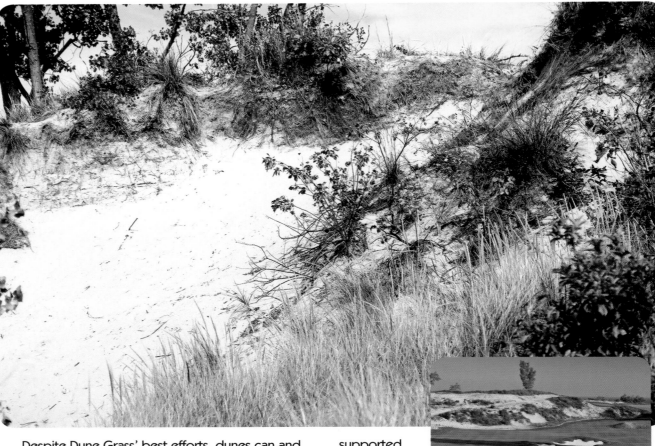

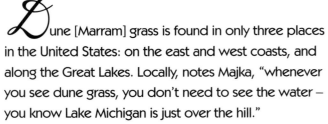

*D*une [Marram] grass is found in only three places in the United States: on the east and west coasts, and along the Great Lakes. Locally, notes Majka, "whenever you see dune grass, you don't need to see the water – you know Lake Michigan is just over the hill."

Marram grass, sun-burnt in the summer to the color of sand, is the quintessential "sandbinder." Unlike other plants, including dune flowers, Marram grass has adapted to being covered up by blowing sand. Far from dying, it simply throws off new shoots that rapidly break the surface. Over time, the resulting network of long, tough roots and generations of covered-over grass stems create thick, tough mats that capture and hold sand like no other substance – better, by far, than sand fences.

European settlers learned this virtue at once. 17th century Massachusetts Bay colonists were required, under penalty of law, to plant Marram grass along the seashore each April, preserving beachfronts on what is now Martha's Vinyard and Provincetown.

Despite Dune Grass' best efforts, dunes can and do "move." For example, when a tree topples over, the resulting hole in the sand creates a gap that can act as a wind tunnel. Storm winds can punch a gap through the sturdiest Marram grass "defense." But these "blowouts" are essential to the evolution of the dunes, and are themselves home to some native flowers, such as Michigan's Pitcher's Thistle, that are choked out of the impenetrable mats of Marram grass.

The sand traps on the Harbor Shores Golf Course, especially those near Hole 7, uncannily mimic the "blowouts" created by gaps in the Marram grass-supported dunes.

Golfers who hit into the sand traps of the dunes holes may be in for an unpleasant surprise. Jack Nicklaus chose to fill the traps in the Jean Klock Park hole with native, coarse beach sand. "Local sand is heavier and has a very different feel than the finer white sand found at the other holes," notes Ross Smith, Harbor Shores' resident golf pro.

View from Jean Klock Park to the North Pier where the St. Joseph River meets Lake Michigan.

Marram's lesson for golfers: "Perseverance." Dune grass is indomitable. Covered up by blowing sand, it simply sends new shoots to the surface. In this way, dune grass harnesses, anchors, and in a sense conquers the shifting sands. Faced with a setback or new challenge, the golfer should emulate Marram grass: stay anchored; try again.

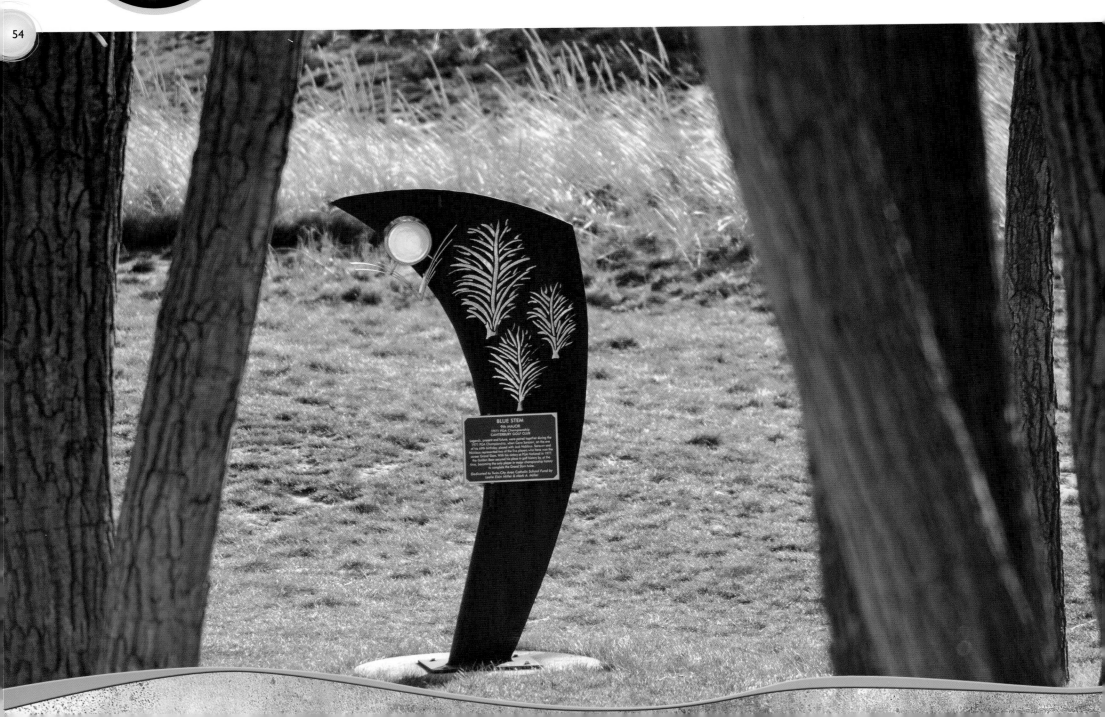

BLUE STEM
9th MAJOR

1971 PGA Championship
CANTERBURY GOLF CLUB

Legend, present and future, were paired together during the
1971 PGA Championship, when Gene Sarazen, on his
at his 69th birthday, played with Jack Nicklaus. Sarazen and
Nicklaus represented two of the five players who have won the
career Grand Slam. With his victory at PGA Harbored in 1971,
the Golden Bear secured his place in golf history by, at the
time, becoming the only player in major championship history
to complete the Grand Slam twice.

Dedicated to Twin-City Area Catholic School Fund by
Leslie Elaine Miller & Mark A. Miller

Dedicated to the Twin City Area Catholic School Fund by Leslie Eisen Miller & Mark A. Miller

Scientific Name: Andropogon gerardii [Big Bluestem]; Schizachyrium scoparium [Little Blue Stem]

Bluestem, another important prairie grass, is celebrated in a cutout, see-through form. Backlit, the vivid, stained-glass blue-green colors are positively luminous.

Orange-brown in late fall, Bluestem is named for the distinctive blue-green hue it takes on in spring. Catania's cutout design highlights the color and distinctive "turkey foot" tassel, found on both the Big and Little varieties.

Ross Smith was particularly skeptical about the Bluestem marker when he saw it in Andres'

studio. "It didn't look like much in that dim studio," he recalls. "But when we took it outside, I saw what they were driving at, and this is now one of my favorites."

Along with Indian Grass, Bluestem is the most common prairie grass, and the most important. Big Bluestem, "chief of the tallgrass country," can grow to ten feet or more -- so high that only a tall man astride a horse could see into the distance. Little Bluestem, half as tall, thrives in mixed-grass prairies and at the edges of Big Bluestem stands.

1971 PGA Championship - 9th Major

Legends, past and future, were paired together during the 1971 PGA Championship, when Gene Sarazen, on the eve of his 69th birthday, played with Jack Nicklaus. Sarazen and Nicklaus represented two of the five players who have won the career Grand Slam. With this victory at PGA National in 1971, the Golden Bear secured his place in golf history by becoming the only player in major championship history to compete the Grand Slam twice.

ighly nutritious and (evidently) tasty, both Big- and Little Bluestem were staples in the diets of American Bison and other range grazers. To this day, cattle ranchers call Big Bluestem "ice cream for cows." The fluffy white seeds of the Little Bluestem are among the most valuable food sources for winter birds.

"All flesh is grass." Psalm 103:15.

Bluestem populations were severely reduced when the American prairie was paved or tilled for farming. The grass is enjoying a resurgence of popularity and appreciation. Attractive and hardy, bluestem is extremely drought-resistant once established, and thrives in the blazing sun. Prairie restoration projects often build upon stands of bluestem, which, in addition to stabilizing the soil, provide food, cover and even nesting materials for birds and small creatures.

Bluestem and its relatives such as switchgrass are considered a most promising biofuel. The grasses contain more energy and require less water and fertilizer than corn, and, as perennials, do not need reseeding. These prairie grasses could eventually supplant corn-based ethanol as a leading alternative energy source.

Bluestem's lesson for golfers: "The Long and the Short of it." Fittingly, Hole 9 celebrates the two varieties of Bluestem. Both the towering Big Bluestem and the more modest Little Bluestem are indispensible to a healthy prairie. Similarly, the successful golfer must cultivate both a long and a short game.

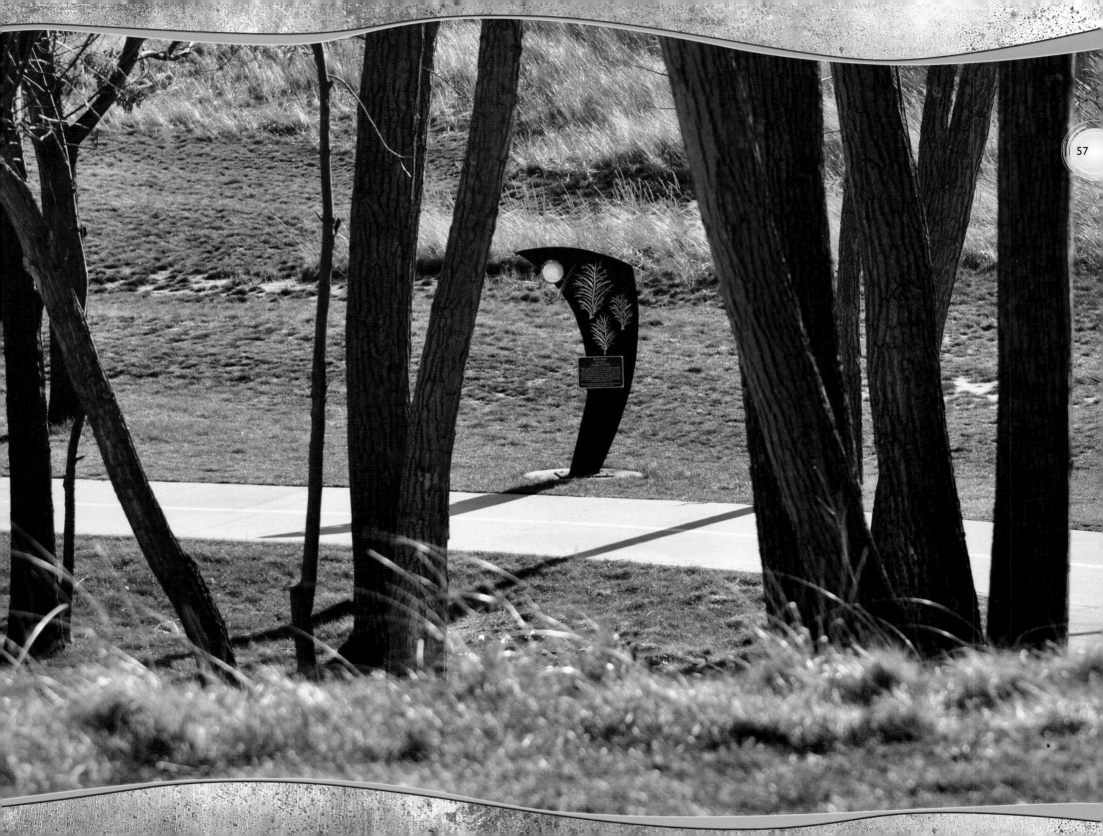

Red Oak

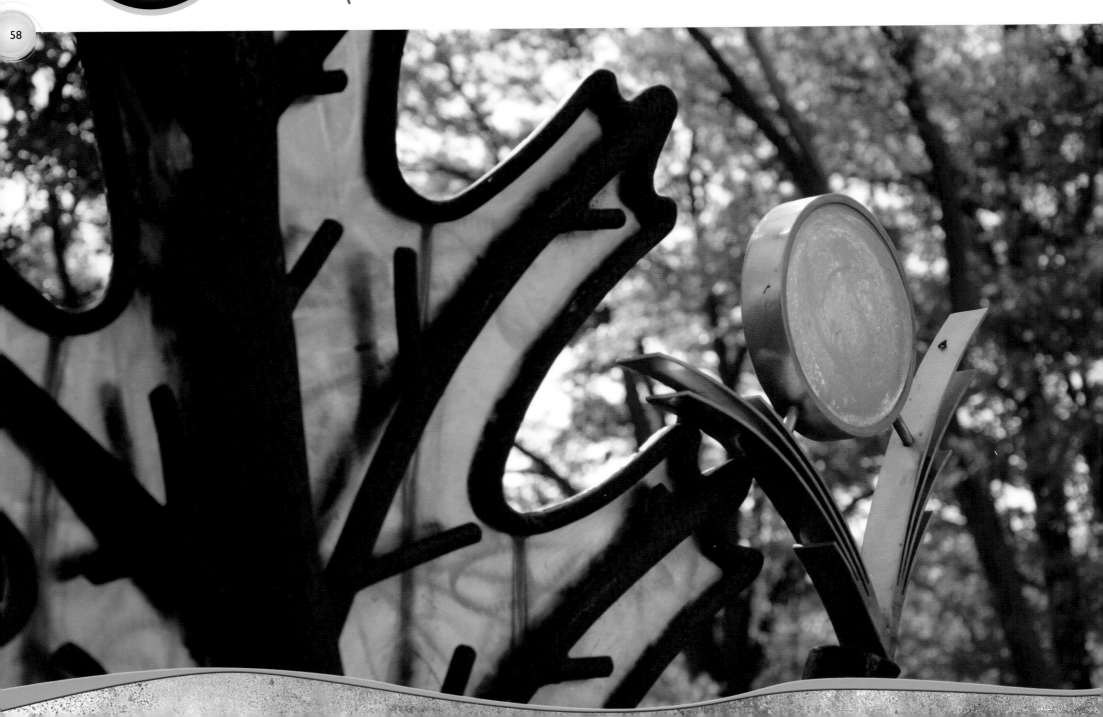

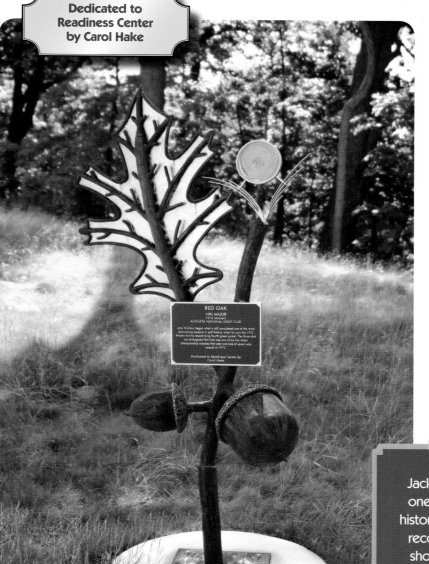

Dedicated to Readiness Center by Carol Hake

RED OAK
10th MAJOR
1972 Masters
AUGUSTA NATIONAL GOLF CLUB

Jack Nicklaus began what is still considered one of the most dominating seasons in golf history, when he won the 1972 Masters for his record-tying fourth green jacket. The three-shot win at Augusta National was one of his two major championship victories that year and one of seven wins overall in 1972.

Dedicated to Readiness Center by Carol Hake

Scientific Name: Quercus rubra

Red Oak is the most classically "sculptural" of the markers, says metal artist Andres. Like the Arrow Arum and Sycamore markers, which emphasized one element of the plant (leaf shape and peeling bark, respectively), the design features the oak's trademark: its large, paired acorns.

Andres' massive, three dimensional Corten acorns are some of the largest elements of any sculpture on the course. As with the Cattail heads, the acorns' rugged caps were perfectly rendered in the dark Corten. Also, like the Cattail heads, passers-by often cannot resist the temptation to pat, tap, rap or rub the textured Corten, to see if it

is as velvety soft as it looks. (It is not.) Some think the grand scale of a small section of a twig and a couple of tiny acorns lends the sculpture a mildly humorous quality.

> Originally, all eighteen markers were plants and flowers, not trees. However, the designers realized that the "hardwood holes" (10-13), with their Northern Michigan setting and feel, should honor trees, so prominent in Michigan's history and so integral to the Harbor Shores golfing experience. The inclusion of five trees (including Hole 18's weeping willow) forced some difficult choices, however. Several strong candidates, such as Purple Coneflower, Indian Paintbrush, Wild Iris and Joe Pye Weed, were cut from the final list.

The outsized leaf employs thick veining overlaying the flat leaf, a technique similar to the Arrow Arum (Hole 7). Here, however, the steel is dark, rather than mirrored, lessening the contrast of leaf and veins.

1972 Masters - 10th Major

Jack Nicklaus began what is still considered one of the most dominating seasons in golf history, when he won the 1972 Masters for his record-tying fourth green jacket. The three-shot win at August National was one of his two major championship victories that year and one of seven wins overall in 1972.

Sacred to Jove, king of the Gods, the Oak has always been a symbol of strength and courage. Perhaps because of its great height, oaks are said to attract lightning, strengthening the association with Jove and other sky gods.

The Red Oak is honored as the "champion" oak, esteemed for its grandeur and its durable, tough wood. With the Sugar Maple (Hole 11), the Red Oak is the "terminal oak" that dominates Michigan's mature, "back dune" climax forests. Michigan's largest Red Oak is found in Berrien County. This giant measured over 23 feet around, with a diameter of seven feet, and stands about 120 feet tall. (Barnes & Wagener, Michigan Trees, (University of Michigan Press, 1992.)

The Red Oak is highly significant in Michigan history. Pioneers used its strong tannic acid to tan leather. They ground its acorns, which (after the tannic acid is leached out) yield a pleasant flour, tasting like a mixture of hazelnut and sunflower seeds. Most important of all, Red Oak lumber is the most valuable oak wood.

Locally, Berrien County's Red Oak lumber was central to the once-thriving shipbuilding industry, which

lasted through the Second World War. Exported to Western states, where it was used for houses and bridges, oak lumber was an important part of Michigan's economy in the 19th and early 20th centuries.

The Oak's original design was a cutout, two dimensional and flat. "It was lifeless," admits Catania. The artists decided to feature the most recognizable elements, enlarging them in three dimensions. The next draft placed the leaf on the bottom, with the acorns on top. "This was backward," Catania continues. Andres moved the various elements around until he found just the right balance and scale.

Seedless for its first fifty years, the Red Oak then produces one of the forest's most prized animal foods: the acorn. Though slightly more acidic than other oaks' acorns, the nutritious and highly caloric Red Oak acorns are a preferred food of the white-tailed deer. As every hunter knows, "Where you find acorns, you'll find deer."

Like many markers, the Red Oak is placed in sight of its namesake plant. The Hole 10 sculpture is particularly "intimate with its environment," in Catania's opinion.

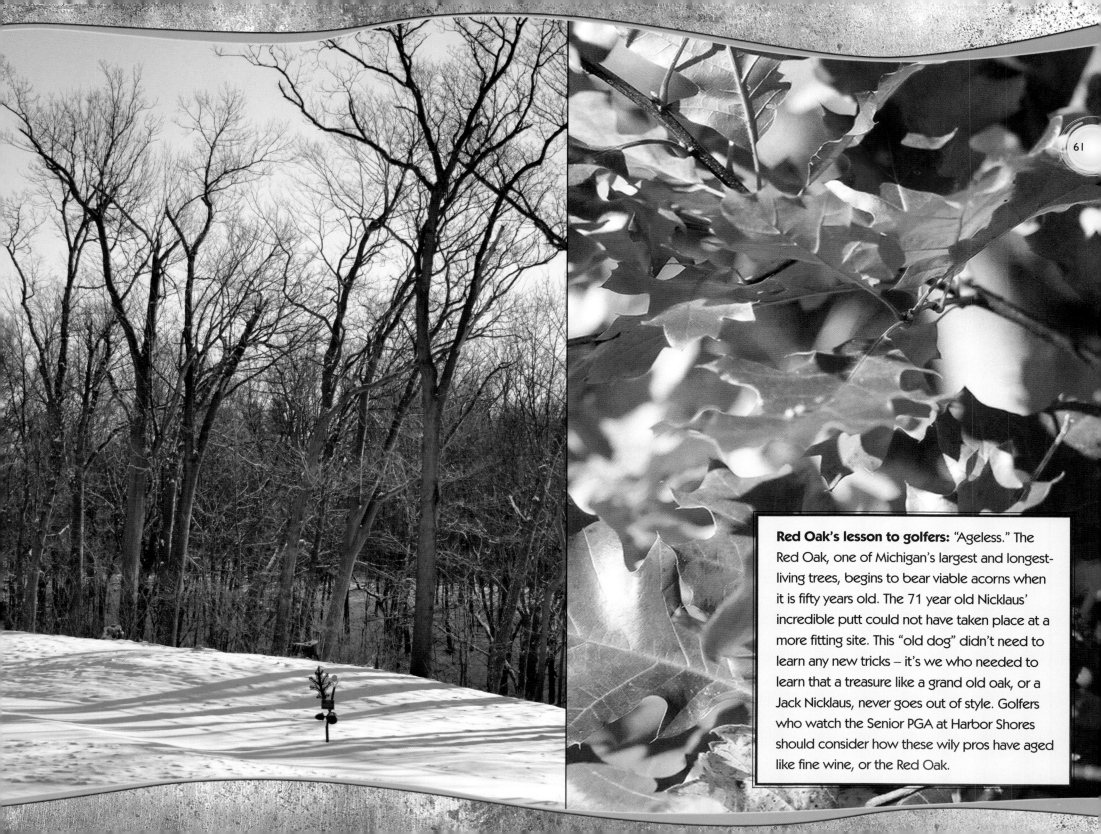

Red Oak's lesson to golfers: "Ageless." The Red Oak, one of Michigan's largest and longest-living trees, begins to bear viable acorns when it is fifty years old. The 71 year old Nicklaus' incredible putt could not have taken place at a more fitting site. This "old dog" didn't need to learn any new tricks – it's we who needed to learn that a treasure like a grand old oak, or a Jack Nicklaus, never goes out of style. Golfers who watch the Senior PGA at Harbor Shores should consider how these wily pros have aged like fine wine, or the Red Oak.

the Putt

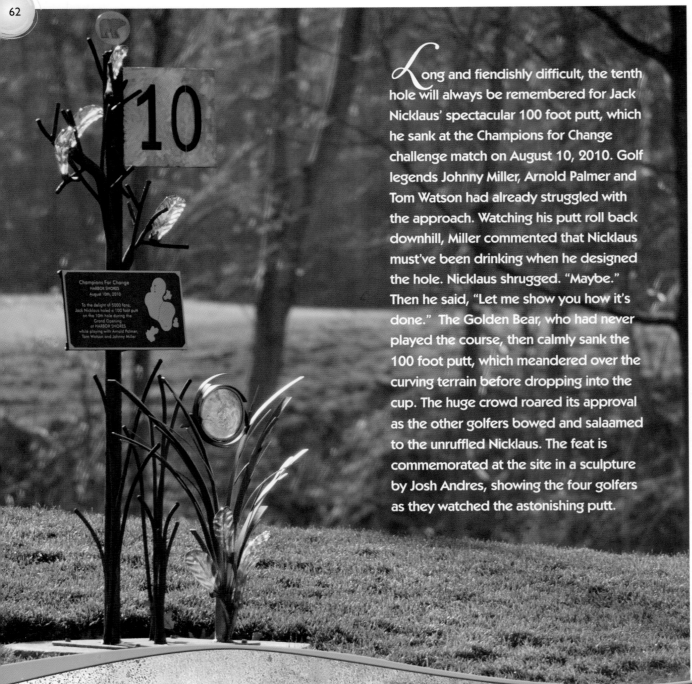

Long and fiendishly difficult, the tenth hole will always be remembered for Jack Nicklaus' spectacular 100 foot putt, which he sank at the Champions for Change challenge match on August 10, 2010. Golf legends Johnny Miller, Arnold Palmer and Tom Watson had already struggled with the approach. Watching his putt roll back downhill, Miller commented that Nicklaus must've been drinking when he designed the hole. Nicklaus shrugged. "Maybe." Then he said, "Let me show you how it's done." The Golden Bear, who had never played the course, then calmly sank the 100 foot putt, which meandered over the curving terrain before dropping into the cup. The huge crowd roared its approval as the other golfers bowed and salaamed to the unruffled Nicklaus. The feat is commemorated at the site in a sculpture by Josh Andres, showing the four golfers as they watched the astonishing putt.

Champions For Change
HARBOR SHORES
August 10th, 2010

To the delight of 5000 fans, Jack Nicklaus holed a 100 foot putt on the 10th hole during the Grand Opening at HARBOR SHORES while playing with Arnold Palmer, Tom Watson and Johnny Miller

To the right: Holding their trophies are Jack Nicklaus, Tom Watson, Arnold Palmer, and Johnny Miller.

This marker was funded by "Golf Carts for the Arts"

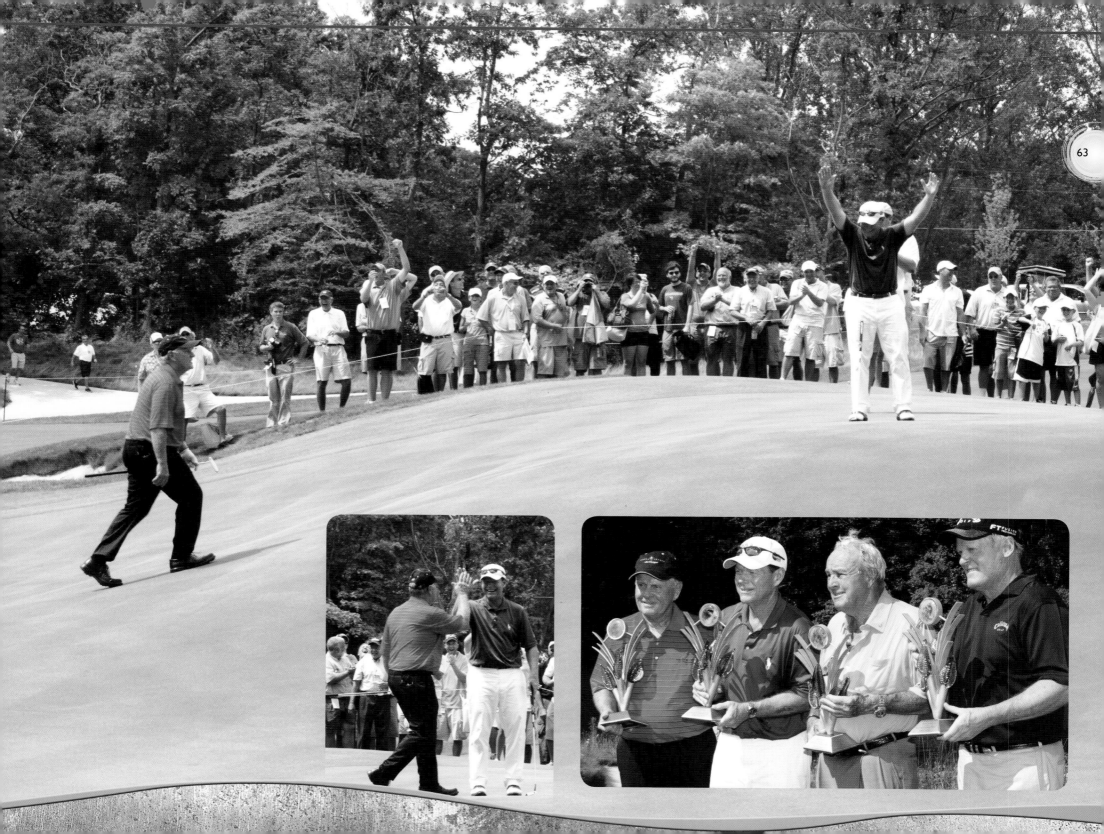

Sugar Maple

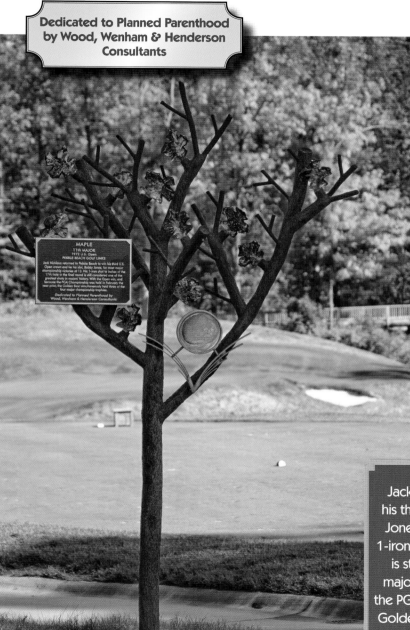

Scientific Name: Acer Saccharum
Common names: Hard Maple, Rock Maple

Few trees are as important to Michigan's history and economy as the Sugar Maple. Unlike "soft" maples, the Sugar Maple is long-lived, hard, hardy and stable, known for its staying power and dependability. Sugar maples can grow to 120 feet in height, and live 200 years or more.

Sugar Maples and Red Oaks (Hole 10) make a natural pairing. As the giants of the woods, they "dance together" in a Michigan climax forest, remarks Naturalist Chuck Nelson. "What art can surpass the rows of maples and oaks?" asked Thoreau after visiting the Maine woods. (HDT Journal, 7/12/1852.)

1972 U.S. Open - 11th Major

Jack Nicklaus returned to Pebble Beach to win his third U.S. Open Crown and tie his idol, Bobby Jones, for most major championships at 13. His 1-iron to inches on the 17th hole in the final round is still considered one of the greatest shots in majors history. With the Open win, and because the PGA Championship was held the prior year, the Golden Bear simultaneously held three of the four major championship trophies.

The notched, life-sized glass maple leaves on the tee marker have a hidden (and not-so hidden) meaning. Their red-into-green coloring suggests the transition from summer to fall colors. Now count them: eleven in all. Asked if this number is just a coincidence, Catania remarked slyly, "Maybe I was thinking of the eleventh hole, maybe not. Eleven leaves just seemed right. We couldn't add or take away and keep the balance." Indeed, Catania recalls, "the eleventh leaf was the hardest one to place."

Catania's original design was two dimensional, with the maple leaves and seeds presented as cutouts in the trunk. The revised sculpture is three-dimensional, with the eleven leaves carefully placed on the branches.

The Sugar Maple is named for its copious flow of sweet sap in the springtime. In a typical year, a mature tree yields hundreds of gallons of sap, more than any other maple. Better still, Sugar Maple sap is the sweetest of all, meaning more syrup per tree. Even so, it takes about 40 gallons of Sugar Maple sap to produce one gallon of maple syrup.

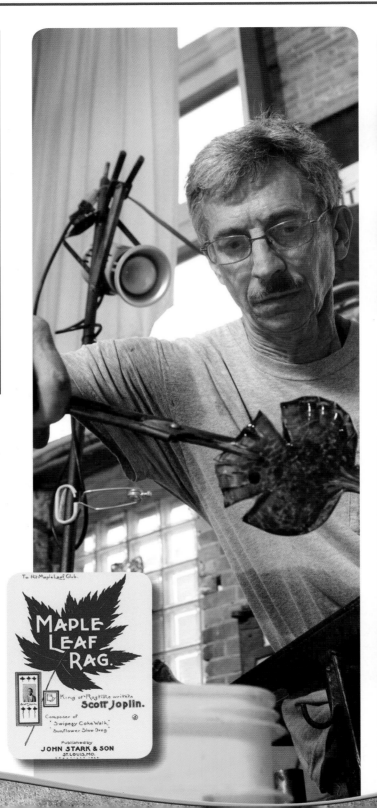

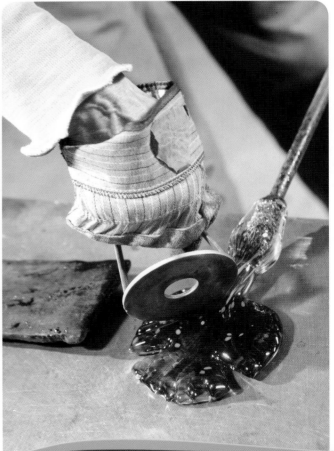

As depicted, the Maple's metal branches are large compared to the poured glass leaves, and are highlighted by their rugged texture. The emphasis on the "wood" is intentional. Like the Red Oak, the Sugar Maple's high-grade lumber was crucial to Michigan's early economy and growth. In the 19th and early 20th centuries, Michigan maples built many of the cities in the prairie states and the west. To this day, Michigan is a leading producer of sugar maple lumber, mainly harvested from sustainable forests.

But there's more. The sugar maple is a wonderful fuel tree, burning long and hot. Its dried logs create the unmistakable "Maple Cured" smokehouse taste. Even its ashes are valuable for potash and alkali.

To the Maple Leaf Club.

MAPLE LEAF RAG.

King of Ragtime writers
Scott Joplin.

Composer of
"Swipesy Cake Walk,"
"Sunflower Slow Drag."

Published by
JOHN STARK & SON
ST. LOUIS, MO.

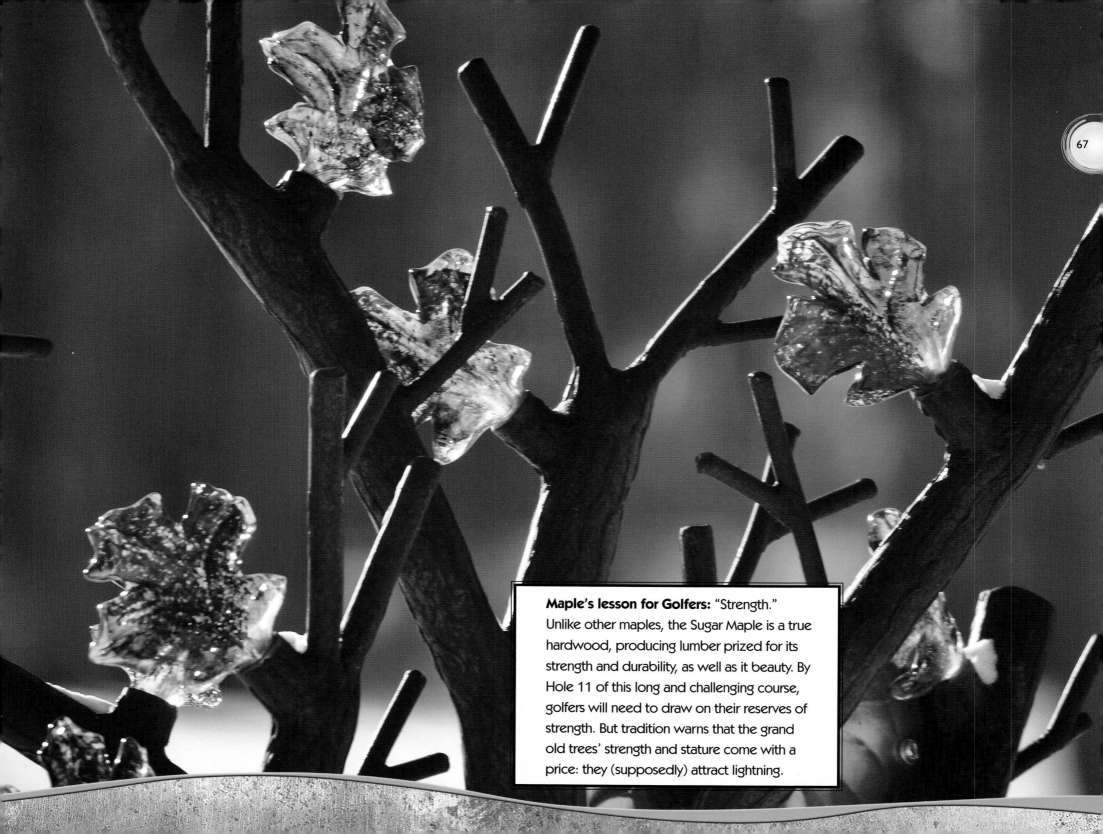

Maple's lesson for Golfers: "Strength."
Unlike other maples, the Sugar Maple is a true
hardwood, producing lumber prized for its
strength and durability, as well as it beauty. By
Hole 11 of this long and challenging course,
golfers will need to draw on their reserves of
strength. But tradition warns that the grand
old trees' strength and stature come with a
price: they (supposedly) attract lightning.

Sassafras

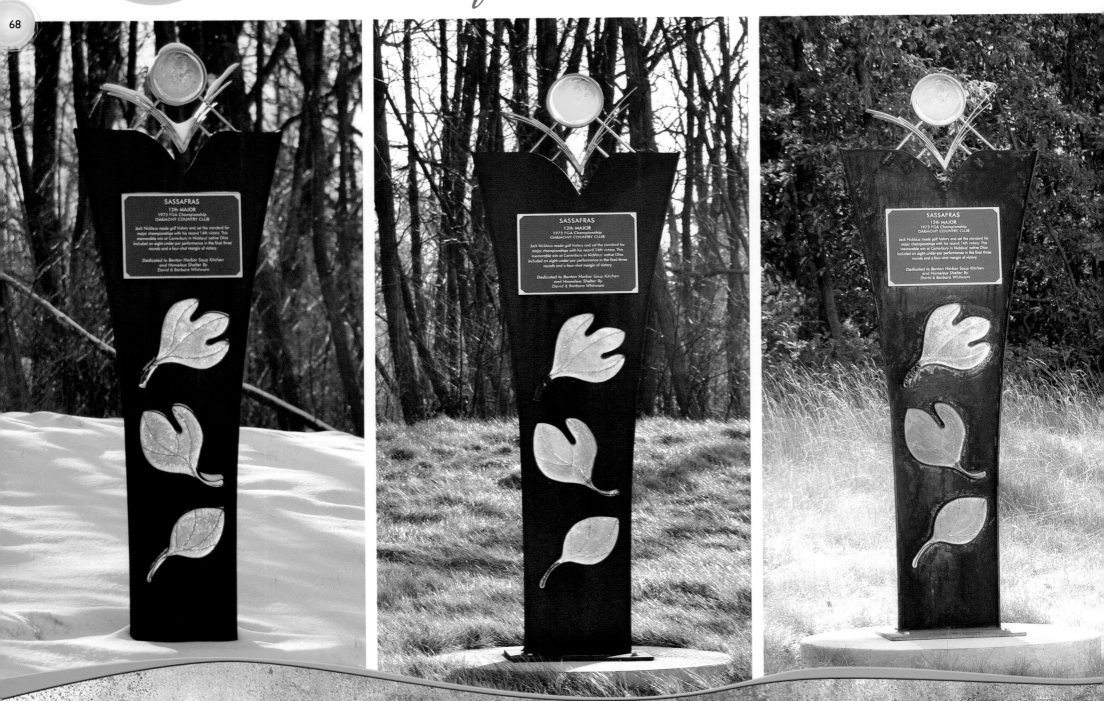

SASSAFRAS
12th MAJOR
1973 PGA Championship
OAKMONT COUNTRY CLUB

Jack Nicklaus made golf history and set the standard for
major championships with his record 14th victory. This
memorable win at Canterbury in Nicklaus' native Ohio
included an eight-under-par performance in the final three
rounds and a four-shot margin of victory.

Dedicated to Benton Harbor Soup Kitchen
and Homeless Shelter By
David & Barbara Whitwam

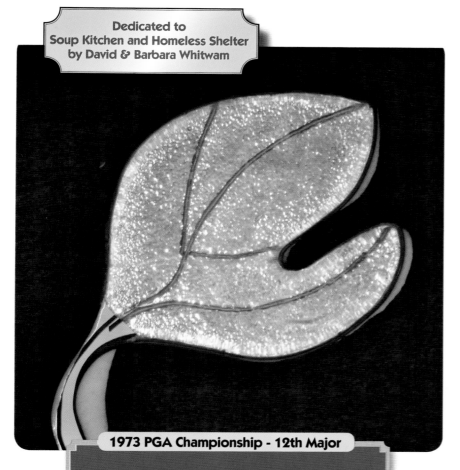

1973 PGA Championship - 12th Major

Jack Nicklaus made golf history and set the standard for major championships with his record 14th victory. This memorable win at Canterbury in Nicklaus' native Ohio included an eight-under-par performance in the final three rounds and a four-shot margin of victory.

Scientific Name: Sassafras albidum
Common names: Mitten tree

The Sassafras tee marker, depicting the tree's three distinct leaf shapes tumbling to the ground, is a particularly happy marriage of steel and glass. "I was glad the designers included Sassafras," said Catania, "because I've always called it the 'Michigan tree' — for the mitten-shaped leaf."

The sassafras is one of the first trees to appear on the fringes of dunes (making it a so-called "early-succession dune species"). Fast-growing and attractive, the tree has long been touted as a medicine, flavoring and food. Sassafras tea is valued for its soothing and calming effect, and the aromatic root is the flavoring for sarsaparilla, or root beer. Its twigs, when scratched, emit an aroma reminiscent of "Fruit Loops." Louisiana's spicy Cajun cooking uses ground Sassafras leaves, called "file," (pronounced "fee-lay") for hearty File Gumbo.

A member of the extensive Laurel family, the sassafras is related to such varied plants as the avocado, cinnamon tree, and camphor tree.

A rounded metal shield encases the three leaf cutouts. Andres and Catania collaborated to find just the right angle and spacing for the three different leaf types. Catania then made molds of the cutouts, cast the variegated green glass leaves, and fitted them into the marker.

This generally small and short-lived tree has its largest Michigan representative in Berrien County. A recent survey measured this giant as over thirteen feet in girth, four feet in diameter, and ninety feet tall. Barnes & Wagner, Michigan Trees, (University of Michigan Press, 1992).

The sassafras root yields an aromatic oil called safrole, as well as other oils and essences. Safrole-based drinks, including sassafras tea and the original "root beer," were eventually banned by the Food and Drug Administration as a potential carcinogen. Though this ban has been lifted, all brands of root beer now use artificial flavoring.

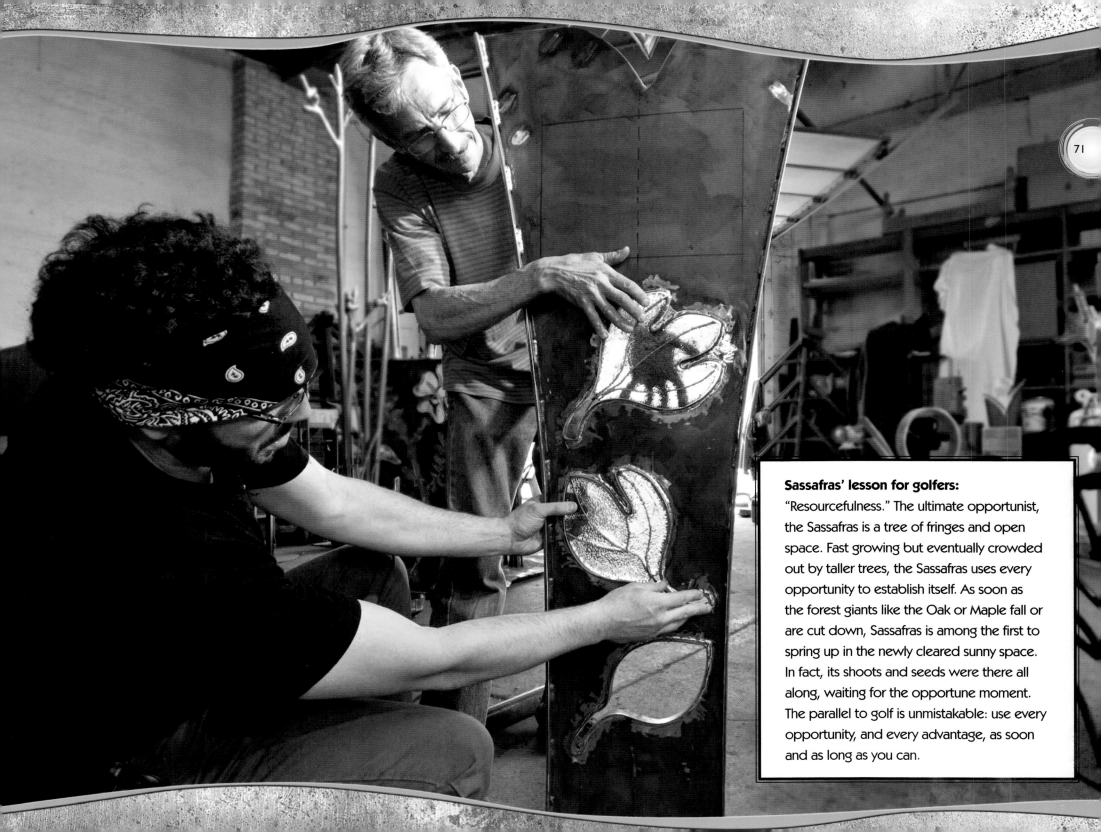

Sassafras' lesson for golfers:
"Resourcefulness." The ultimate opportunist, the Sassafras is a tree of fringes and open space. Fast growing but eventually crowded out by taller trees, the Sassafras uses every opportunity to establish itself. As soon as the forest giants like the Oak or Maple fall or are cut down, Sassafras is among the first to spring up in the newly cleared sunny space. In fact, its shoots and seeds were there all along, waiting for the opportune moment. The parallel to golf is unmistakable: use every opportunity, and every advantage, as soon and as long as you can.

Sycamore

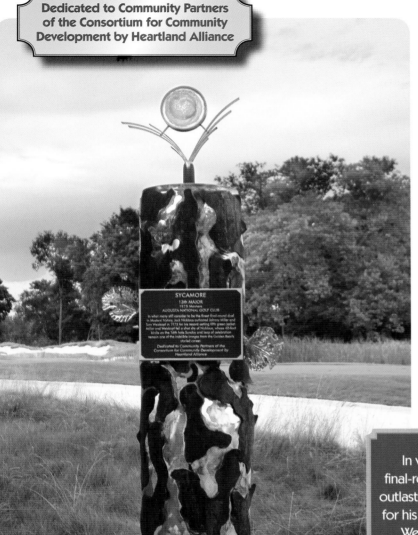

Dedicated to Community Partners of the Consortium for Community Development by Heartland Alliance

Scientific Name: Platanus occidentalis

*T*he stately Sycamores please young and old alike. They dominate a vista with their high canopy and sweeping branches, and with their strong, conveniently spaced, radiating branches, make good climbing trees. Sycamore's notched leaves, resembling a maple's but much larger, are also characteristic.

But "the Sycamore is all about the bark," the artists agreed when they received the commission. Unlike markers depicting other trees, Andres' Sycamore focuses on the trunk, and especially the unmistakable peeling bark. Combining stainless steel and Corten, and using metal smithing techniques

1975 Masters - 13th Major

In what many still consider to be the finest final-round duel in Masters' history, Jack Nicklaus outlasted Johnny Miller and Tom Weiskopf in 1975 for his record-setting fifth green jacket. Miller and Weiskopf fell a shot shy of Nicklaus, whose 40-foot birdie on the 16th hole Sunday, and his leap of celebration remain one of the indelible images of the Golden Bear's storied career.

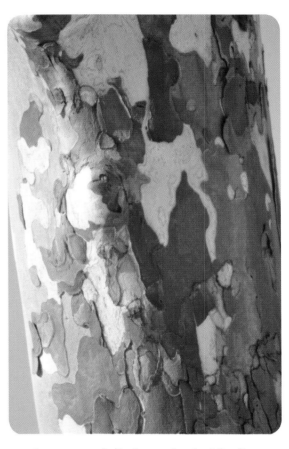

In a process similar to a snake shedding its skin, the Sycamore's outer bark continuously splits and flakes off as the new bark bursts through. The sycamore's distinct peeling bark was always the key to the design. The artists emphasized it even more by rendering only a section of trunk, rather than depicting a whole tree. This allowed Andres to add exquisite detail, in both texture and color, to the signature bark.

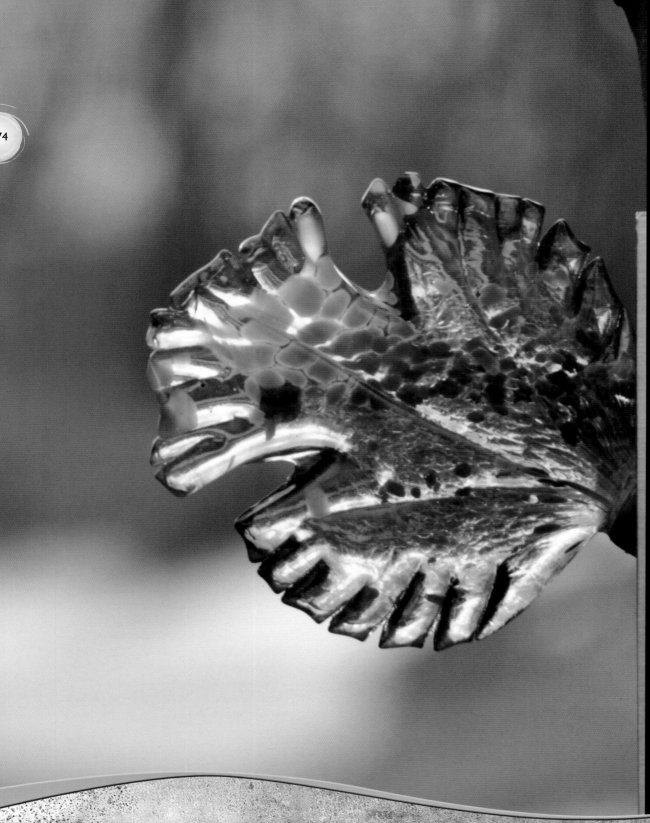

including cutouts, overlays, twisting and bending, Andres' Sycamore trunk is a remarkable rendition of its signature bark. He emphasized it even more by rendering only a section of trunk, rather than depicting a whole tree. This allowed Andres to add exquisite detail, in both texture and color, to the signature bark.

*A*ll trees shed some bark, as with each spring, a new bark layer grows and swells just beneath the outer surface. The Sycamore takes this "exfoliation" process to the extreme, rapidly growing new bark and just as rapidly shedding the old. The result is the Sycamore's unmistakable "camouflage" pattern, in tan, gray, brown, white and yellow.

The Sycamore has an ancient lineage, and is among the largest trees in North America. Some are said to have grown 70 feet in 17 years, and to live for 500 years or more. The largest Sycamore known has a trunk more than fifteen feet in diameter.

The Sycamore is also noted for its resiliency. Chopped down, its stump will quickly sprout new shoots, which in time can develop into a strong new tree in its own right. Catania's two colorful leaves, spread like waving hands from the plaque, hint at this eagerness for rebirth.

Michigan, and Berrien County in particular, is the Sycamore's northeastern-most range.

Though the Sycamore sculpture celebrates its unique bark, Jerry's gorgeous leaves, peeping out from the plaque add a colorful, almost playful touch.

Vying with numerous competitors for the honor, the noble Sycamore's inclusion as a tee marker was locked in after the designers saw this stately tree, visible from the marker.

*"My neighbor inhabits a hollow sycamore,
and I a beech tree."*

— Thoreau

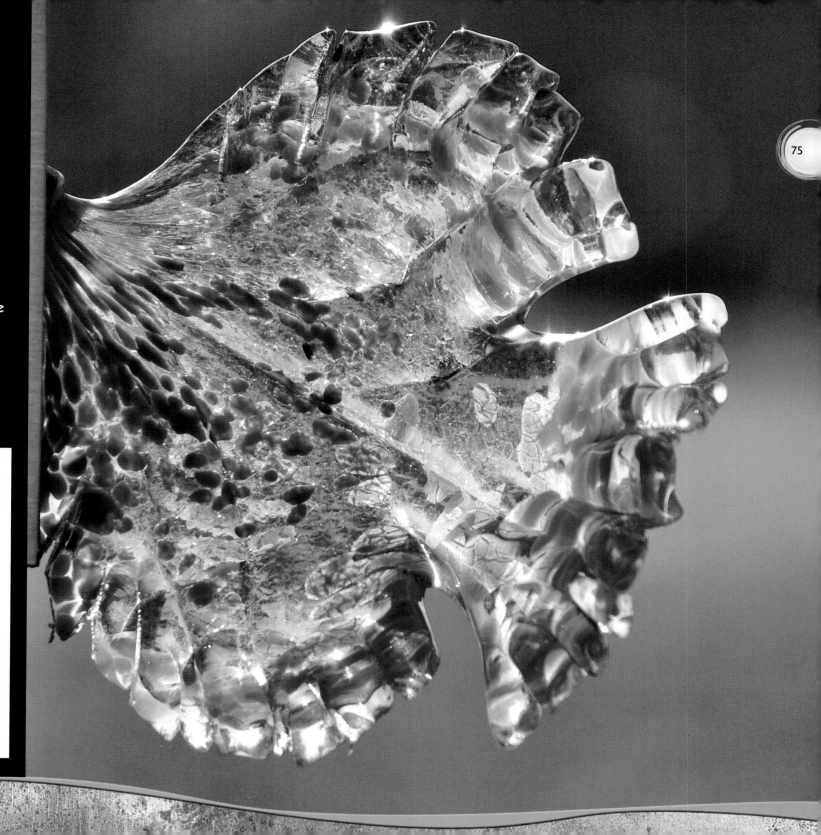

The Sycamore was sacred to the Egyptian goddess Hathor, who represented renewal, perhaps because of its self-regenerating bark. Native Americans called the Sycamore the "ghost tree" because of its white bark in winter. And Sycamore is associated with another kind of spirit: its sap makes a tolerable beer or wine!

Sycamore's lesson for golfers: "Renewal." Constant, aggressive renewal is the hallmark of the Sycamore's bark. A Sycamore's stump sprouts vigorous shoots that can quickly develop into large trees. Golfers, likewise, should continuously revisit, review and renew their technique and tactics. When necessary, they should be ready to start over, from the ground up – just like the Sycamore.

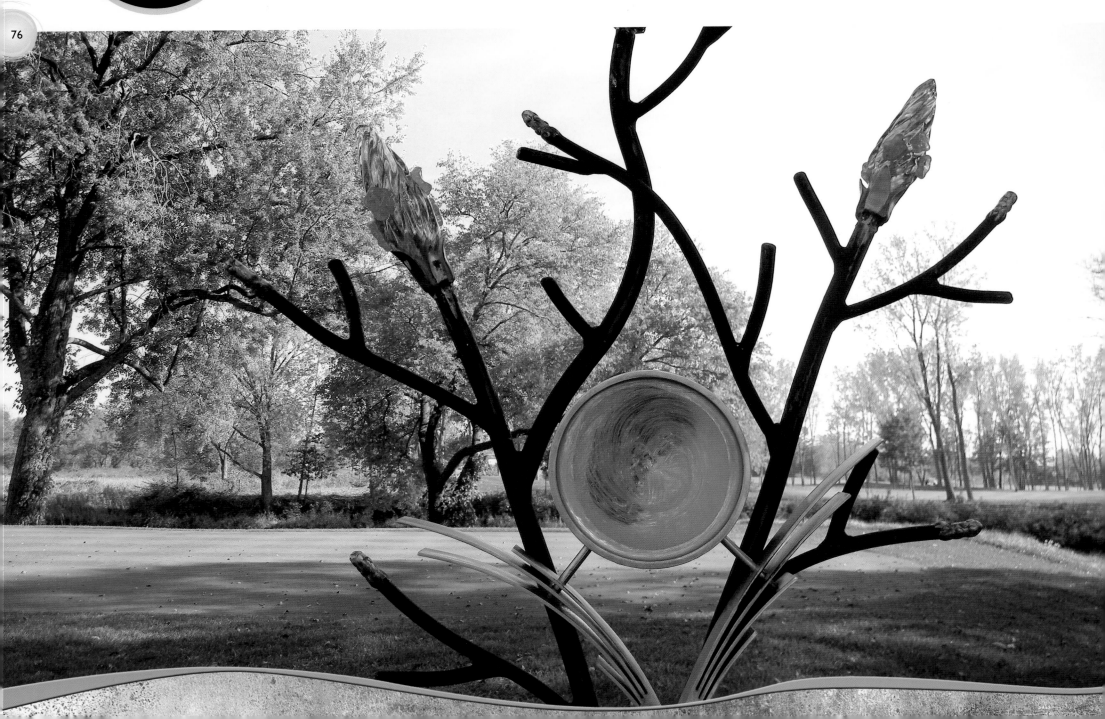

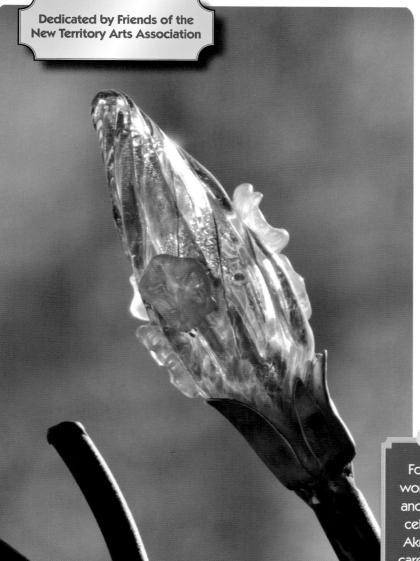

Scientific Name: Verbena hastata
Common Name: Wild Hyssop, Simpler's Joy, Herbalist's Joy, Herb of Grace, Herb of the Cross
Blooming season: July-August

A favorite aroma for scented candles and soaps, the vervain (verbena) is a common, but easily overlooked native flower. The artists' interpretation highlights its buds with a vivid green that "pops out," as well as its tiny purple flowerets. The sculpture's symmetry and detail is uncannily similar to the plant's description in a popular book from a century ago: "With its "beady, rocket-like flowering spikes," the vervain is like "an elaborate, equally balanced floral candelabra." Frederick William Stack, *Wildflowers Every Child Should Know* 1914, p. 350.

The Celebration logo receives special treatment in this sculpture. To emphasize the vivid green glass buds, Catania added a pronounced, sparkly green swirl to the logo's yellow circle. "Our original instruction was to keep the logo absolutely uniform in color," recalls Catania. "Over time, the committee members trusted us more and more, and we started adding little touches of color. Everyone seems pleased with the result."

1975 PGA Championship - 14th Major

For the fourth time in his career, Jack Nicklaus won two major championships in the same year and he did so by adding another chapter to his celebrated history at Firestone Country Club in Akron, Ohio. Nicklaus recorded one of his fifth career victories, helped by a third-round 67 that created an eight-shot swing between himself and second-round leader Bruce Crampton.

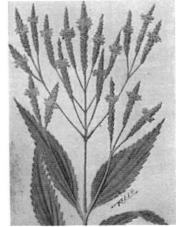

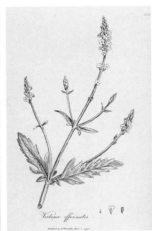

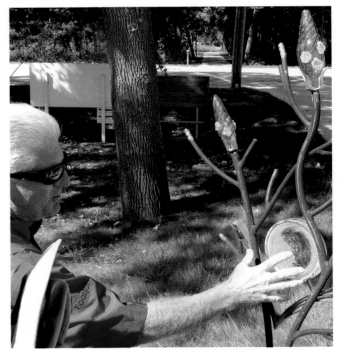

*V*erbena has fascinated mankind throughout the ages. Christian tradition says that Jesus was anointed with verbena after his death on Calvary. Native Americans used its powdered flower to stop bleeding.

Magical lore gives Vervain a curiously double nature. A standard ingredient in the witches' cauldron, it was also an effective countercharm, "gainst witchcraft much availing." [Drayton] Woven into bridal wreaths to symbolize purity, the flower itself is notoriously wanton, interbreeding into hybrids so readily that the existence of a "pure" strain is much in debate.

The artists admit that Vervain presented the biggest problem for placing the Celebration logo. "We took turns holding it up various places for the other," says Catania. Eventually, Andres placed it at the very center. "Looking back, it was the only possible place," Catania adds.

Vervain has a short blossoming "window," displaying its delicate purple flowers for only six weeks in midsummer. For this time, the riverbanks and meadows are a sea of purple, but before and after, the vervain is virtually unnoticeable. To ensure that the Harbor Shores Golf Course would be attractive all season long, designers planted and restored native flowers and trees that had differing blooming periods. From early spring through fall, golfers and nature lovers will always find beauty on the course and its environs.

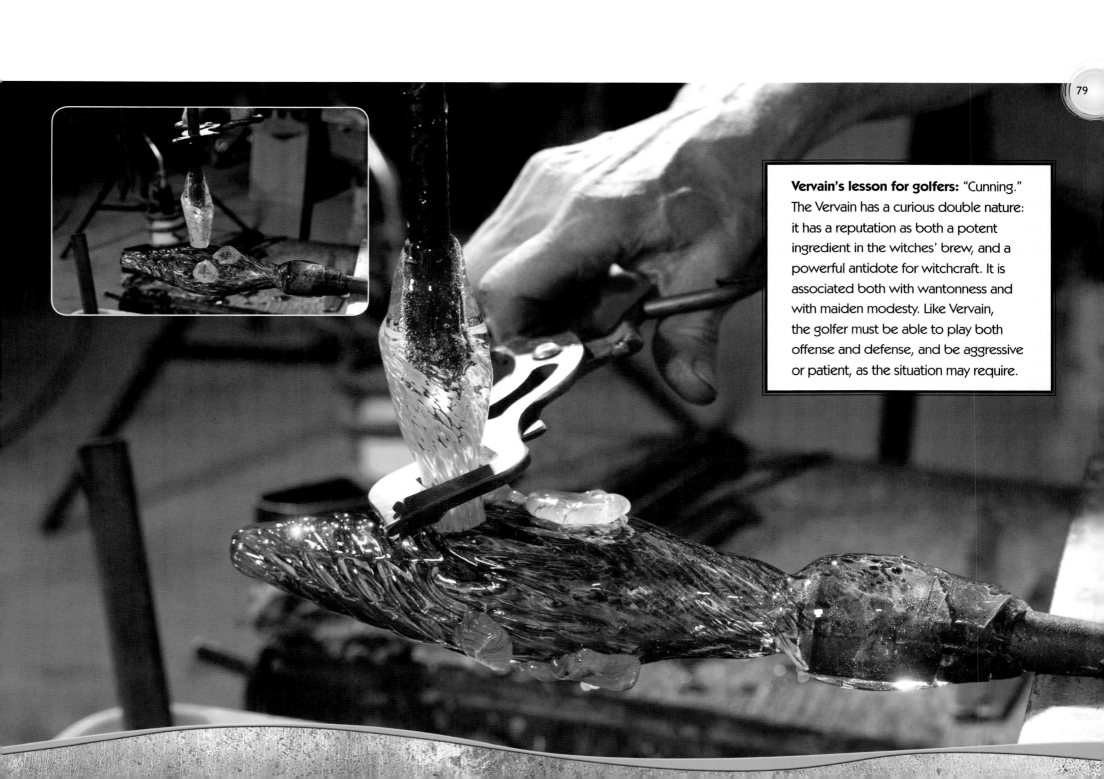

Vervain's lesson for golfers: "Cunning." The Vervain has a curious double nature: it has a reputation as both a potent ingredient in the witches' brew, and a powerful antidote for witchcraft. It is associated both with wantonness and with maiden modesty. Like Vervain, the golfer must be able to play both offense and defense, and be aggressive or patient, as the situation may require.

Primrose

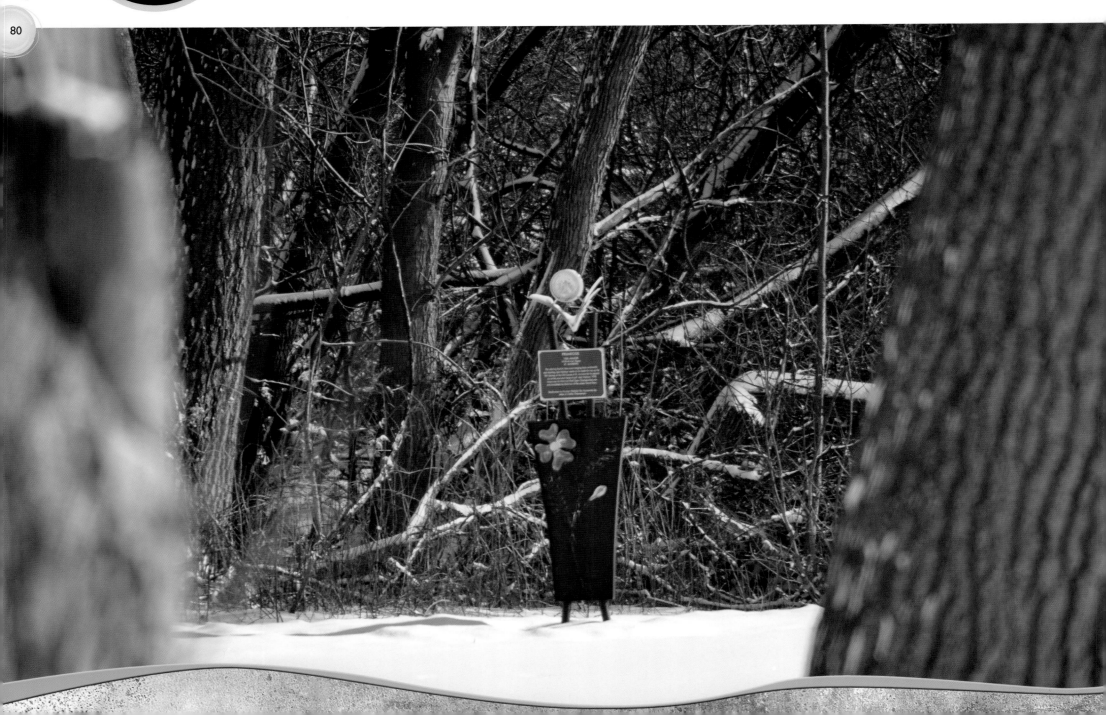

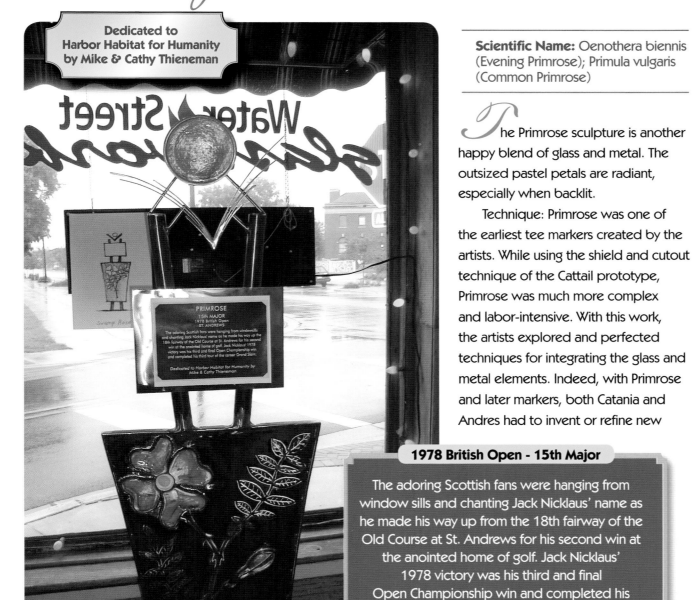

Dedicated to Harbor Habitat for Humanity by Mike & Cathy Thieneman

PRIMROSE
15th MAJOR
1978 British Open
ST. ANDREWS

The adoring Scottish fans were hanging from windowsills and chanting Jack Nicklaus' name as he made his way up the 18th fairway of the Old Course at St. Andrews for his second win at the anointed home of golf. Jack Nicklaus' 1978 victory was his third and final Open Championship win and completed his third tour of the career Grand Slam.

Dedicated to Harbor Habitat for Humanity by Mike & Cathy Thieneman

Scientific Name: Oenothera biennis (Evening Primrose); Primula vulgaris (Common Primrose)

The Primrose sculpture is another happy blend of glass and metal. The outsized pastel petals are radiant, especially when backlit.

Technique: Primrose was one of the earliest tee markers created by the artists. While using the shield and cutout technique of the Cattail prototype, Primrose was much more complex and labor-intensive. With this work, the artists explored and perfected techniques for integrating the glass and metal elements. Indeed, with Primrose and later markers, both Catania and Andres had to invent or refine new

techniques and methods.

Based on a design by Catania, Andres created the shield and made the cutouts. He then gave Catania "cookie cutter" outlines of the cutouts. Catania transferred these shapes to sand cast molds, and poured the glass in. The glass pieces were then carefully fitted into the cutouts, and sealed with silicon glue.

1978 British Open - 15th Major

The adoring Scottish fans were hanging from window sills and chanting Jack Nicklaus' name as he made his way up from the 18th fairway of the Old Course at St. Andrews for his second win at the anointed home of golf. Jack Nicklaus' 1978 victory was his third and final Open Championship win and completed his third tour of the career Grand Slam.

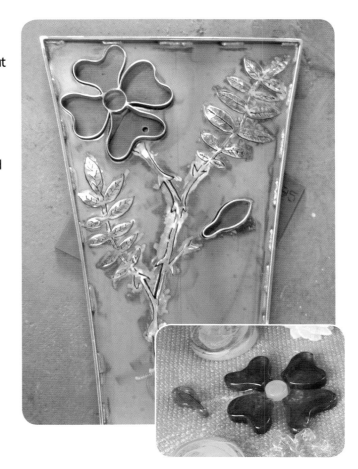

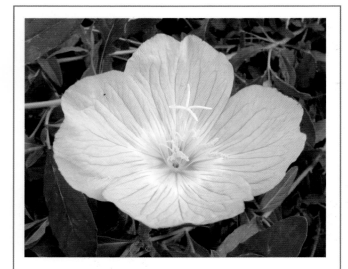

"The beautiful leaf clusters of the primrose are remarkable for their wonderful symmetrical arrangement and … are a perfect pattern for the modeler, the sculptor, decorator or wood-carver." William Hamilton Gibson, 1892. The artists' elegant rendition confirms the venerable Mr. Gibson's opinion.

𝒜 striking design element is the lacy see-through quality of the leaves. The artists had originally intended to fill in all of the cutouts with glass. However, once the flower was in place, they realized that the remaining, delicate cutouts nicely integrated the background into the viewer's experience.

What makes this rose "prim" is its habit of closing its flowers during the day. Open only at night, it provides nectar for nocturnal moths. Most prominent

of these is the pink Primrose Moth, which has been described as burying itself in the open blossom and "binge-nectaring" like "a drunk passed out at a bar." (Bryan Pfeiffer).

The primrose has a fragrant aroma – but it emits a chemical that can irritate the skin, or even the nose of someone who "stops to smell the roses!"

Golfers may find it hard to believe that the scenic Hole 15 was once an immense dump. When Jack Nicklaus was slated to view the site, developer Mark Heseman had bulldozers part the trash, working down to ground level. When Nicklaus drove along the new path, the trash on either side was higher than the SUV he was driving. "Mark, how do you find these places?" was Nicklaus' laconic comment.

Landscape Restoration by JFNew

*W*ell before work on the course began, JFNew, one of the preeminent landscape restoration groups, conducted a thorough inventory of the property's plant life. The goal of landscape restoration, including the widespread re-introduction of native plants, went hand in hand with course design and construction.

In addition to selecting and surveying the signature plants and trees, JFNew botanists recommended the eradication of some invasive plant species, especially those choking out native plant life. Further, to restore the habitat to a more natural balance, and to enhance the visual appeal of the course from spring through fall, JFNew installed thousands of plants in carefully selected areas. The shopping list of native plants was a long one: New England Aster and Wild Bergamot (over 1100 plants near the tee and the green); Rose Pink and Queen of the Prairie (600 plants in the wetland near the green); Sunflower and Sand Coreopsis (675 yellow wildflowers); Soft-stem Bulrush (400 in the mud flats of the wetland); Yellow Coneflower and Purple Coneflower; Joe-Pye Weed and Vervain (2,600 plants along the Paw Paw River and in the wetlands north of the course); Tall Coreopsis to highlight the existing Primrose population (700 wildflowers); Showy Goldenrod and Black-Eyed Susan (500 yellow wildflowers); Hibiscus (600 plants); and 300 Water Lilies .

When the tee marker project was conceived, JFNew botanists were asked to select eighteen signature plants. Initially, all eighteen holes were to be named for flowers or plants, not trees. However, the woodlands spanning holes 10-13, and the importance of the lumber industry to Berrien County's history, led to the selection of four special trees (and some of the course's most striking markers).

The original vision was limited to native trees and flowers. However, when the designers saw the setting of Hole 18, an exception was made for an import, the Weeping Willow, honoring the venerable, hump-backed giant that dominates the view from the tee.

In the end, the selection of plants and trees does justice to the immense variety of habitats in Southwest Michigan, in Berrien County, and on the course itself. Subject species range from the miniscule aster to the massive oak and maple; from the drab bulrush to the fragrant vervain and "show-offy" hibiscus; from the ever-present Black-Eyed Susan to the rare, protected Rose Pink.

The sculptures, with their variety of techniques and artistic vision, differ from each other as much as the plants they interpret. But in the end, the lifelike water lily and eerily abstract Weeping Willow, the flamboyant hibiscus and minimalist bulrush have an overriding unity. All reflect the artists' resolve to capture what is timeless and essential in each subject.

*P*rimroses have a long history in Europe, and were important in the rituals of the Druids. Perhaps for this reason, the Primrose has always been associated with fairies. For the same reason, the "following the primrose path" means taking the easy or even immoral road to possible destruction:

"Do not, as some ungracious pastors do,
Show me the steep and thorny way
to heaven,
Whiles, like a puff'd and reckless libertine,
Himself the primrose path
of dalliance treads
And recks not his own rede."

Ophelia to Laertes, Hamlet

Primrose's lesson to golfers: "Hard Work." As attractive as the primrose may be, golfers must avoid the "primrose path of dalliance" – that is, they must choose the rugged, disciplined approach over the easy or lazy way.

Blackeyed Susan

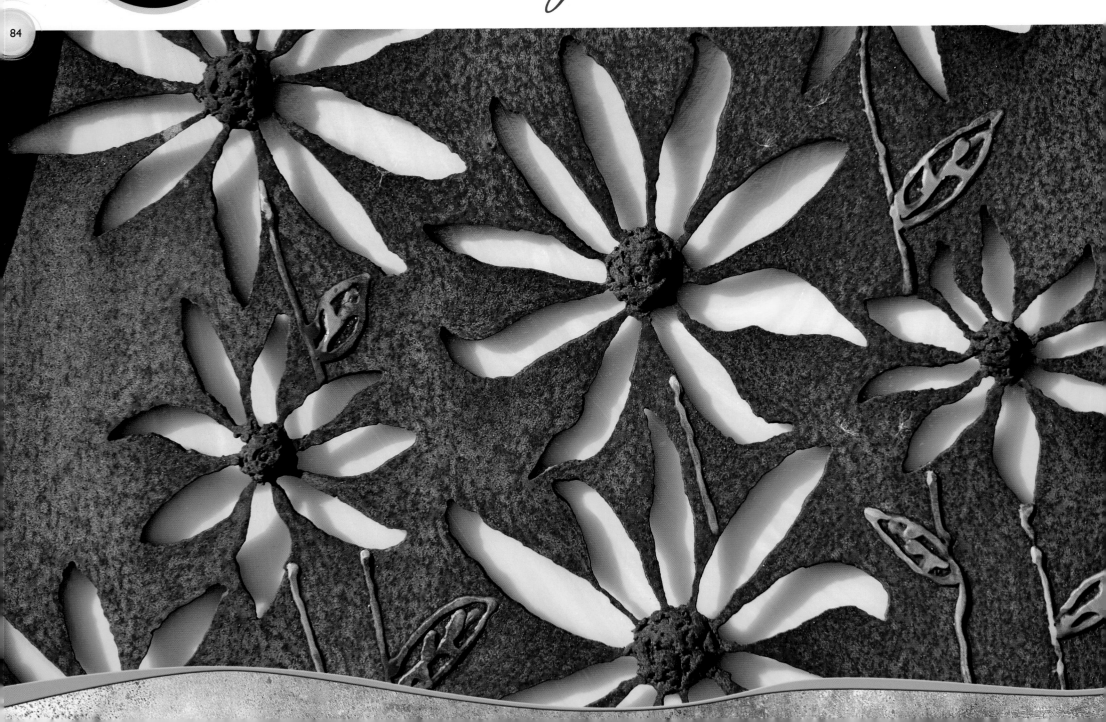

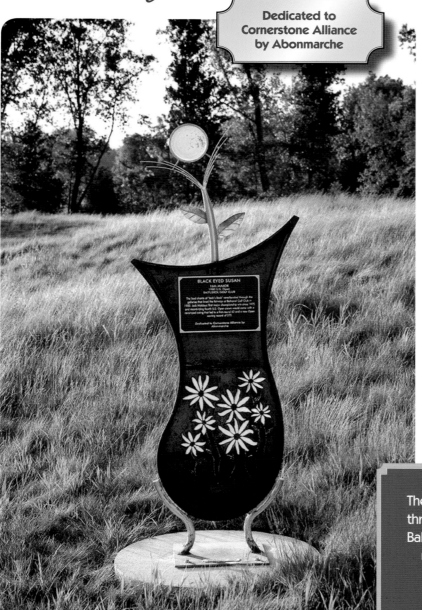

Dedicated to Cornerstone Alliance by Abonmarche

Scientific Name: Rudbeckia hirta
Common names: Ox-Eye Daisy, Gloriosa Daisy

Hole 16 celebrates America's most common wildflower, the Blackeyed Susan.

Black-Eyed Susan's design employs the "shield" form and see-through cutouts, rather like the Bluestem (Hole 9). Here, the flowers' vivid yellow pops through, like the plant itself in sunshine. While each flower follows the same basic form, each is slightly different in detail. "When you see a field of Black-eyed Susans, or sunflowers or even Bluestem grass for that matter, each plant looks the same from a distance," notes Wilczak. "But if you look carefully, close-up, you'll always find something unique, something special, about each one."

1980 U.S. Open - 16th Major

The loud chants of "Jack's Back" reverberated through the galleries that lined the fairways at Baltusrol Golf Club in 1980. Jack Nicklaus' first major championship win since 1975 and record-tying fourth U.S. Open crown would come with a revamped swing that held to a first-round 63 and a new Open scoring record of 272.

Saucy little Black Eyed Susan,
When her Mother caught her snoozin'
Rubbed her sleepy eyes and said
She guessed she'd toddle off to bed.
— Pioneer Nursery Rhyme

While she enjoys full sun, Blackeyed Susan can tolerate a variety of conditions, from dry prairie to moist ditches and fringes of forest. This member of the aster family – cousin to the Sunflower (Hole 3), New England Aster (Hole 1), and even the ubiquitous dandelion – was prized by Native Americans and pioneers for its medicinal qualities, and was used to treat ailments ranging from snakebites and earaches to worms.

Naturalists consider the Blackeyed Susan a "backbone plant" for its importance to the ecosystem. Its sweet nectar attracts and nourishes butterflies, bees and beetles; its seeds are a rich food for finches and other small birds.

The generic term "daisy" is derived from "day's eye," the evocative large, dark centers that look like the dilated pupil of an eye. The extract of another plant, called belladonna, was a "beauty secret" of women in the middle ages, as it dilated the pupil of the eyes – rather like Black-eyed Susan's!

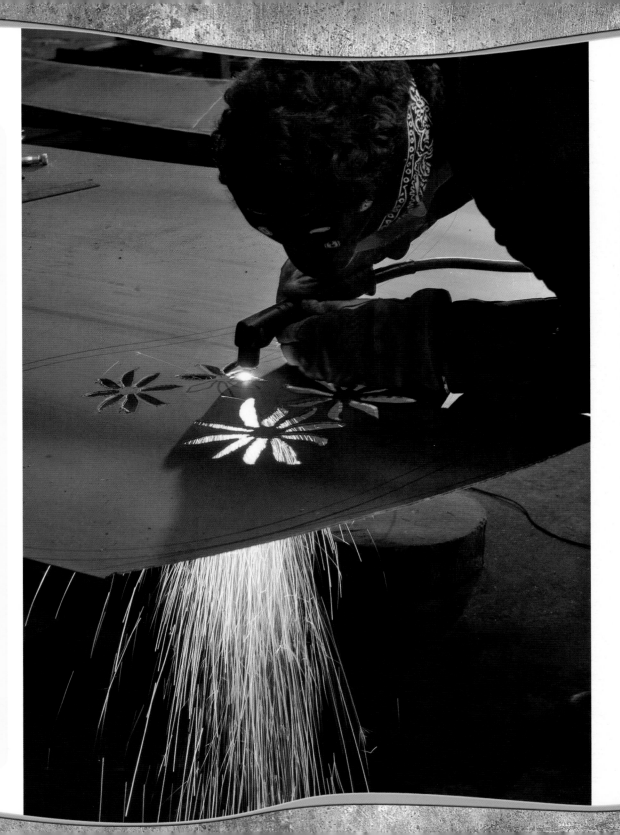

Black-eyed Susan is also celebrated in a romantic legend associated with another wildflower, Sweet William, which blooms at about the same time. As described by poet John Gay: "All in the downs the fleet was moored, banners waving in the wind. When Black-eyed Susan came aboard, and eyed the burly men. 'Tell me ye sailors, tell me true, if my Sweet William sails with you.'" Gardeners often plant the two flowers together, and make mixed bouquets of the two wildflowers. To this day, the original "Susan's" identity remains a mystery.

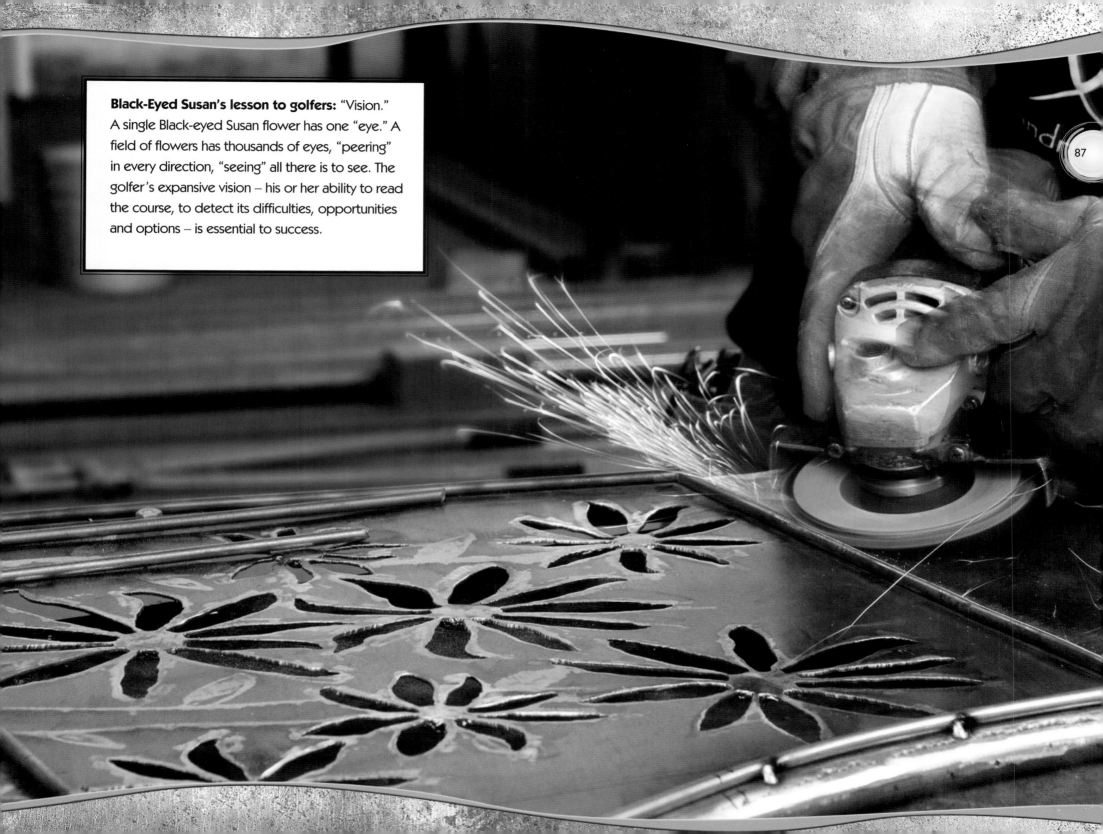

Black-Eyed Susan's lesson to golfers: "Vision." A single Black-eyed Susan flower has one "eye." A field of flowers has thousands of eyes, "peering" in every direction, "seeing" all there is to see. The golfer's expansive vision — his or her ability to read the course, to detect its difficulties, opportunities and options — is essential to success.

Hibiscus

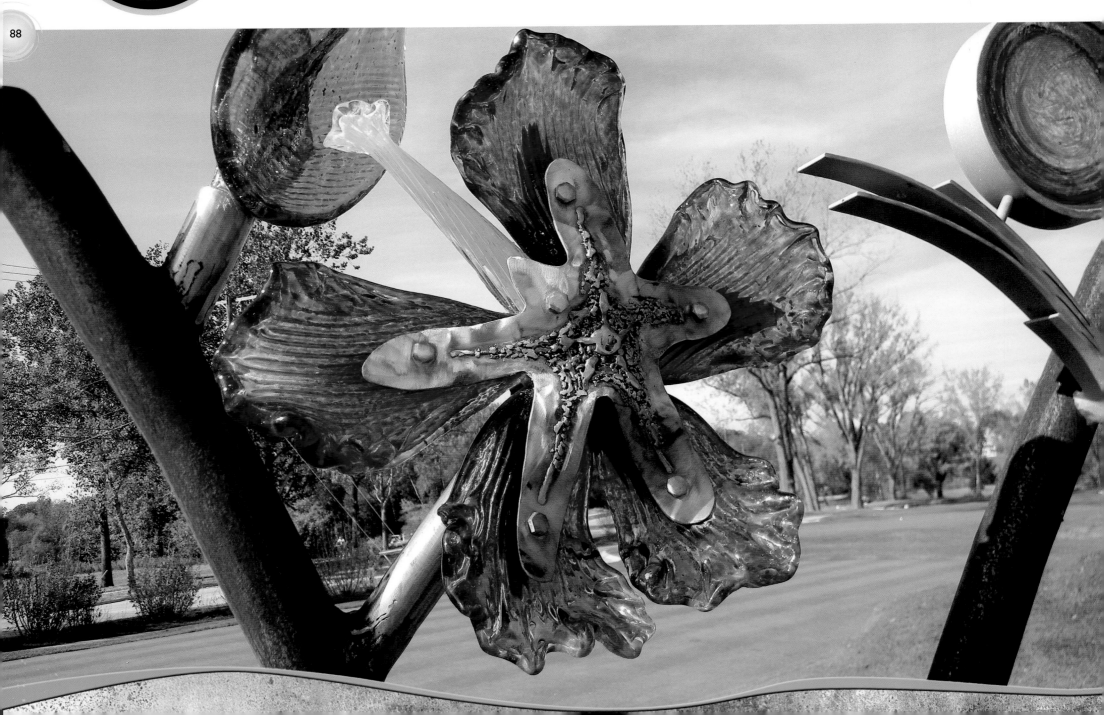

**Dedicated to
Benton Harbor Street Ministry/
Band of Brethren in Christ
by Dr. Marcus Robinson & Pamela Miller**

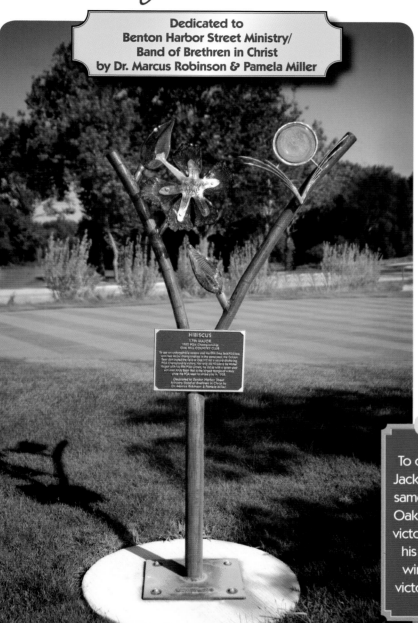

Scientific Name: Hibiscus grandiflorus
Common Names: Marsh Mallow,
Swamp Rose Mallow

**"Hibiscus is the antithesis
of subtle."**
— Restoration Botanist Brian Majka

*T*he extravagantly large, extravagantly ornate hibiscus inspired perhaps the most visually striking tee marker. Josh overlaid Jerry's bounteous glass flower with an intriguing, starfish-like steel stamen, in an almost science-fiction touch.

Hibiscus flower
Beautiful smile of summer

— Dorothy Alva Holmes

1980 PGA Championship - 17th Major

To cap an unforgettable season and the fifth time Jack Nicklaus won two major championships in the same year, the Golden Bear dominated the field at Oak Hill for a record-shattering PGA Championship victory. Not only did Nicklaus tie Walter Hagen with his fifth PGA Crown, he did so with a seven-shot win over Andy Bean that is the largest margin of victory since the PGA went to stroke play in 1958.

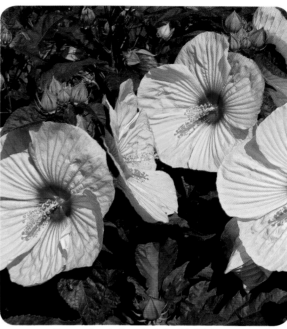

The wetlands "explode" with Hibiscus…

While most markers were designed primarily to be viewed from the front (as golfers drive by) the Hibiscus is equally interesting viewed "in the round."

The gaudy hibiscus flower retains its ruby color, even dried and brewed as a nutrient rich tea.

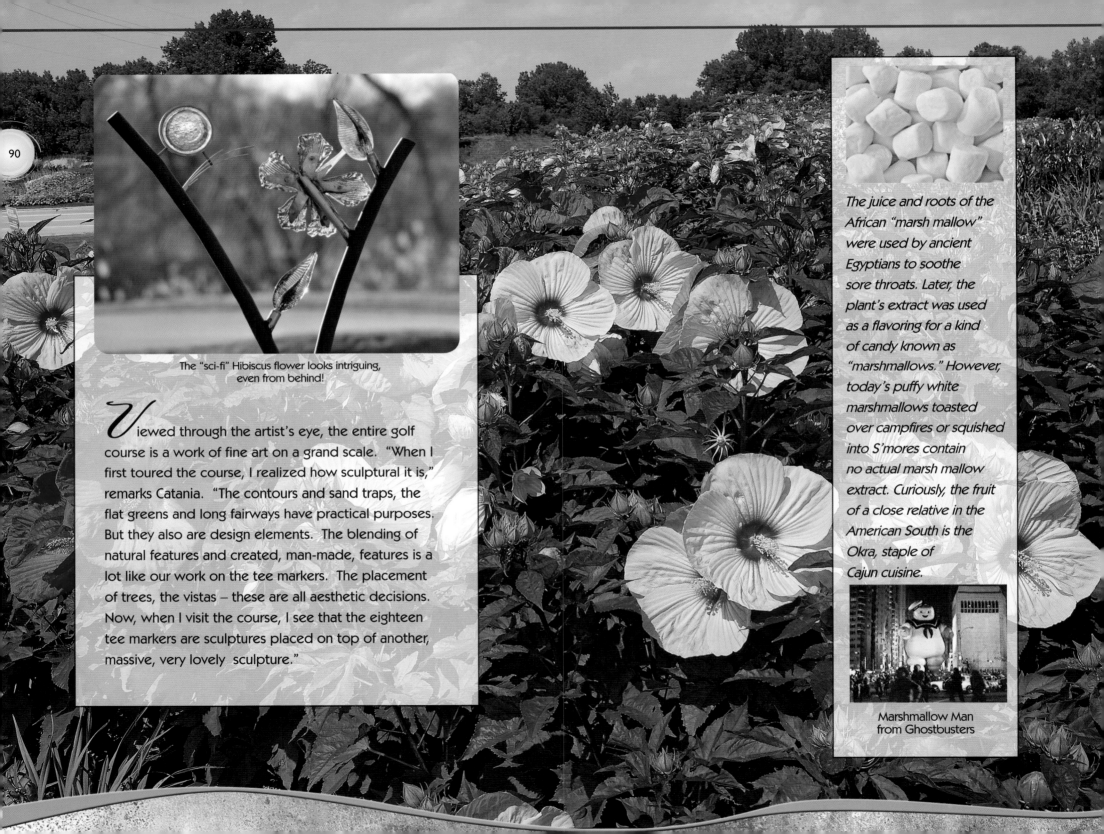

The "sci-fi" Hibiscus flower looks intriguing, even from behind!

*V*iewed through the artist's eye, the entire golf course is a work of fine art on a grand scale. "When I first toured the course, I realized how sculptural it is," remarks Catania. "The contours and sand traps, the flat greens and long fairways have practical purposes. But they also are design elements. The blending of natural features and created, man-made, features is a lot like our work on the tee markers. The placement of trees, the vistas – these are all aesthetic decisions. Now, when I visit the course, I see that the eighteen tee markers are sculptures placed on top of another, massive, very lovely sculpture."

The juice and roots of the African "marsh mallow" were used by ancient Egyptians to soothe sore throats. Later, the plant's extract was used as a flavoring for a kind of candy known as "marshmallows." However, today's puffy white marshmallows toasted over campfires or squished into S'mores contain no actual marsh mallow extract. Curiously, the fruit of a close relative in the American South is the Okra, staple of Cajun cuisine.

Marshmallow Man from Ghostbusters

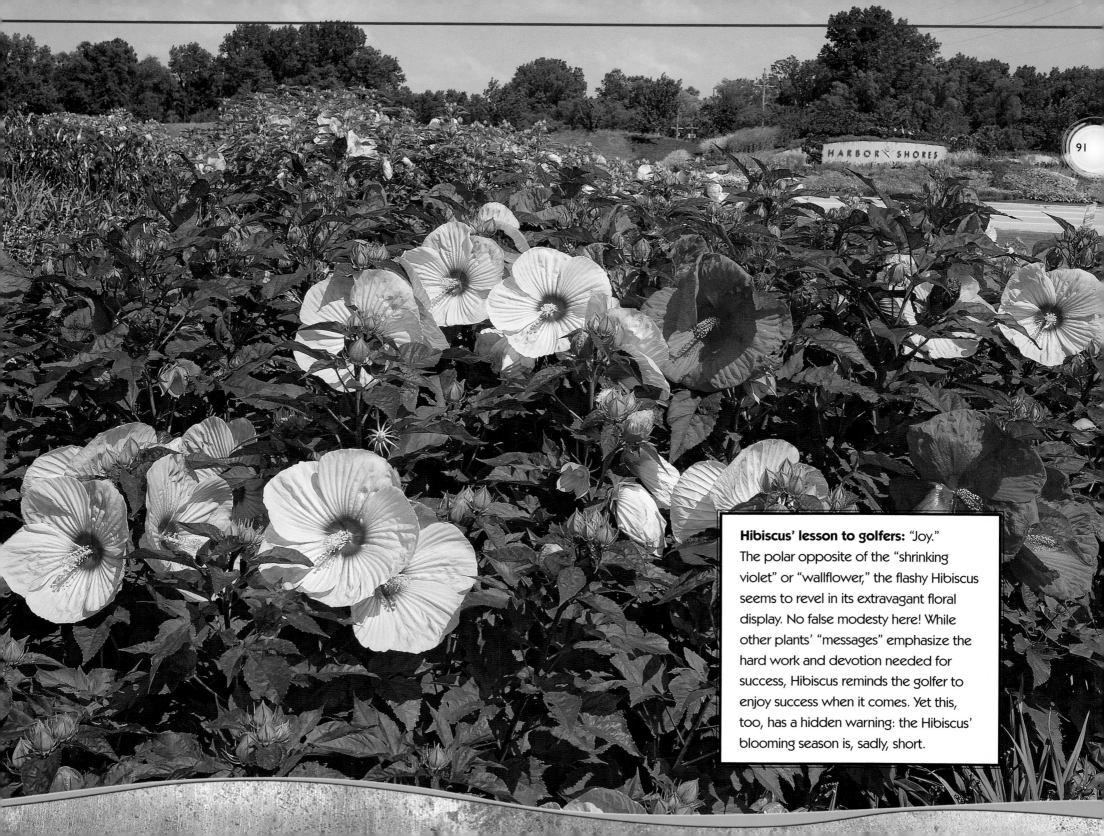

HARBOR SHORES

Hibiscus' lesson to golfers: "Joy."
The polar opposite of the "shrinking violet" or "wallflower," the flashy Hibiscus seems to revel in its extravagant floral display. No false modesty here! While other plants' "messages" emphasize the hard work and devotion needed for success, Hibiscus reminds the golfer to enjoy success when it comes. Yet this, too, has a hidden warning: the Hibiscus' blooming season is, sadly, short.

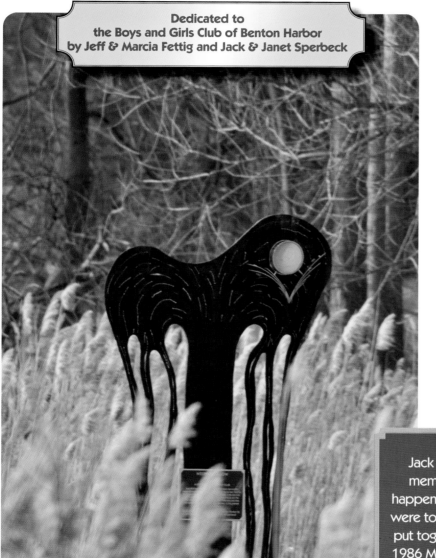

**Dedicated to
the Boys and Girls Club of Benton Harbor
by Jeff & Marcia Fettig and Jack & Janet Sperbeck**

Scientific Name: Salix Babylonica

"The course starts with a bang at Hole 1, with its outsized, showy, amazing Aster. I knew the experience had to end with a bang – something the golfer would remember, but also something completely different."

—Josh Andres

The final sculpture, Hole 18's Weeping Willow, is definitely "something completely different."

At first glance, the Weeping Willow is the most mysterious, even oddest, of the tee markers. The dark, hump-backed silhouette with its drooping tresses has been compared to an elephant, to fireworks, clouds – even to the Addams' Family's eerie, hairy "Cousin Itt."

Now, focus your eyes beyond the marker and its inspiration is clear: the magnificent Weeping Willow just across the river, with its signature outline and cascade of branches.

Of all of the tee marker flora, Weeping Willow is the only non-native plant. "Originally, the 18th hole was going to be Hibiscus or even Iris," said designer Brian Majka. "But once we came on-site, we realized we had to pay tribute to that majestic old willow that dominates the view from the tee."

1986 Masters - 18th Major

Jack Nicklaus will tell you today that his most memorable major championship victory also happens to be his last. Told his clubs and his game were too rusty to compete, a 46 year-old Nicklaus put together a stirring final round of 65 to win the 1986 Masters with his sixth green jacket. Historians and fans still contend that his victory, just like the man, is the greatest in the game's history.

The Weeping Willow is the only "kinetic" (moving) sculpture in the tee marker series. Its drooping branches, paired and welded for a three dimensional element, sway and creak in high winds. Along with the Cattail, Weeping Willow is one of the markers most frequently touched by golfers and other viewers. It is also one of four markers made entirely of metal, with only the Celebration logo adding a glass element.

Representation versus Interpretation

"Ultra-realistic" art, art that looks like what it represents, is not open to interpretation. It is what it is." says Susan Wilczak, public art expert. "Stylized art, such as the Weeping Willow marker, is always open to interpretation, and no two people will see it the same way."

Josh Andres was surprised at how many golfers took time to chat, ask questions and even thank him for helping make the tee markers. "Many of them said they'd never thought much about art," he says. "They'd never seen sculptures like this on a golf course, and told me it added to the whole experience."

"EVOLUTION OF A DESIGN."
Weeping Williow had more prototypes than any other marker. First conceived as bare branches it evolved into a solid cup-shaped design (with cutouts) before attaining its final form, humpbacked with flowing tresses.

Weeping willows, along with native relatives such as the Black Willow, are prodigiously "thirsty" trees, able to absorb huge quantities of water through their deep, broad root systems. This makes the willow indispensible to flood management, especially in low-lying areas near rivers or ponds. Willows are among the very few trees that can tolerate standing in water for limited periods of time. Indeed, Weeping Willows often have a "toe [root] in the water."

The Weeping Willow, named for its drooping, cascading branches, originated in China. It was somewhat misleadingly named Salix Babylonica, or the Babylonian Willow, as it is often associated with Psalm 137:

"By the rivers of Babylon,
there we sat down and wept...
and hung our harps on the willows thereon."

Old-timers said that a person with a heavy heart and no one to talk to should confide in a weeping willow: "Confess to a willow and your secret will be safe." At the end of this grueling 18 hole course, some golfers may indeed have something to "confess" to the sculpture, or to its majestic model on the opposite bank.

Weeping Willow's lesson for golfers:

"Contemplation." With the eighteenth hole comes the final tally and the trip to the clubhouse. The end of the grueling course invites contemplation of the day's experience, its highs and lows, its signs of progress and areas for growth. What better seed of deliberation than the ambiguous Weeping Willow sculpture? While some golfers may indeed be tempted to shed a tear over shanks, slices and blown putts, the enigmatic Weeping Willow sculpture, which can change from tree to cloud to fireworks in the blink of an eye, reminds us to keep matters in context, to use the lessons learned for the next round. So, no regrets. There's always tomorrow – not to mention, the nineteenth hole!

"Willow, Weep For Me" is a much-recorded popular
jazz standard written in 1932 by Ann Ronnell, (who also
wrote "Who's Afraid of the Big Bad Wolf?")

Willow weep for me
Willow weep for me
Bent your branches down along the ground
and cover me
Listen to my plea
Hear me willow and weep for me
Gone my lovely dreams
Lovely summer dreams
Gone and left me here
To weep my tears along the stream
Sad as I can be
Hear me willow and weep for me
Whisper to the wind and
say thy love has sinned
To leave my heart a sign
And crying alone
Murmur to the night
Hide her starry light
So none will find me sighing
Crying all alone
Weeping willow tree
Weeping sympathy
Bent your branches down along the ground
and cover me
Listen to me plea
Hear me willow and weep for me
Willow, willow, weep for me

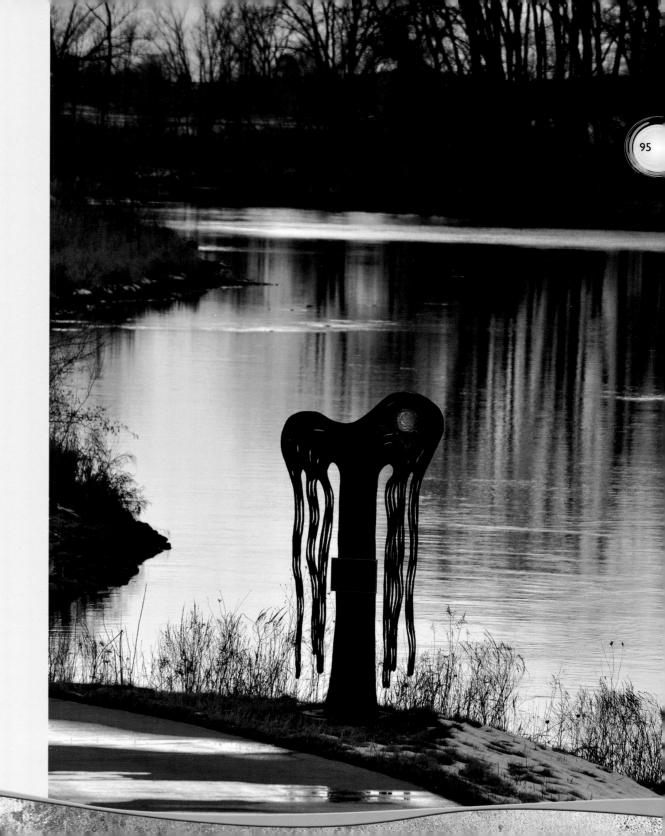

Day Lily

Dedicated to the
Whirlpool Foundation
by Jeff and Judy Noel

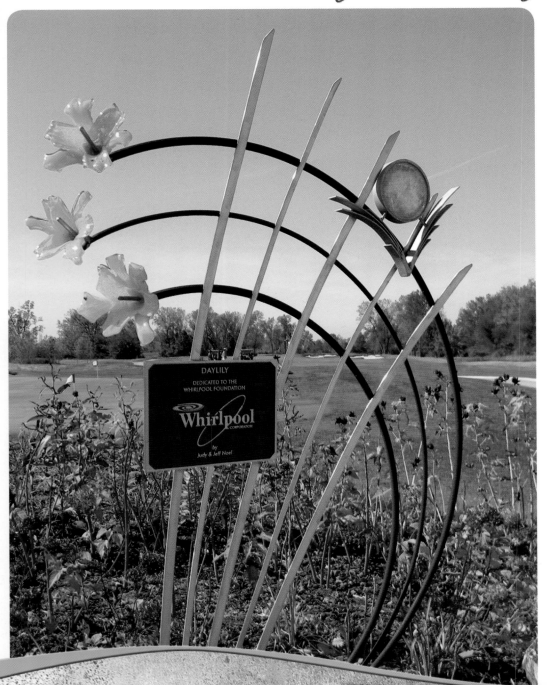

Scientific Name: Hemerocallis lilioasphodelus

The Day Lily, the sculpture golfers will see at the clubhouse, was among the last to be created. Inspired by plantings already in place when the sculpture was commissioned, the Day Lily is the only purely ornamental and fully "domesticated" plant honored with a sculpture.

In fact, the day lily is now so widespread in open or uncultivated fields that it is often mistaken for a wildflower. Its proliferation and wide range is reflected in its alternative names: Roadside Lily, Railroad Lily, and even Outhouse Lily!

The Day Lily sculpture is as notable for its interlaced, curved, sweeping metalwork as for its vivid glass. By the time Day Lily was commissioned, the artists enjoyed the full confidence of their patrons. This, in turn, gave the artists the confidence to create this large, bold, "introduction" to the clubhouse and to the markers that follow.

Some observers liken the see-through sculpture to a harp or even a musical clef with flower "notes," but this resemblance was not necessarily intentional. "I wanted a sweeping form that your eyes would just naturally follow," says Catania. "But I do like music, so who knows?"

Day Lily's lesson for golfers: "Beauty." The Day Lily sculpture was a kind of afterthought, but what a fine one! Even before they head out to the links, golfers who see the elegant Day Lily can look forward to the unexpected beauty and grace they will find on this magnificent course. Far from an afterthought, the experience of beauty was designed into the course from its inception.

First Tee

"Building character and enhancing lives,
one shot at a time."
Motto, The First Tee of Benton Harbor.

Inaugurated in 2005, The First Tee of Benton Harbor helps youth, aged 6 to 17, to build character and enhance life skills through the game of golf. Housed at the Boys and Girls Club of Benton Harbor, members enjoy the use of a three hole short golf course, a driving range and practice green.

Under Executive Director Ebon Sanders, teachers, mentors and volunteers provide services ranging form golf lessons to homework help. Motivated members can apply for the caddie program, with the opportunity for employment and even college scholarships.

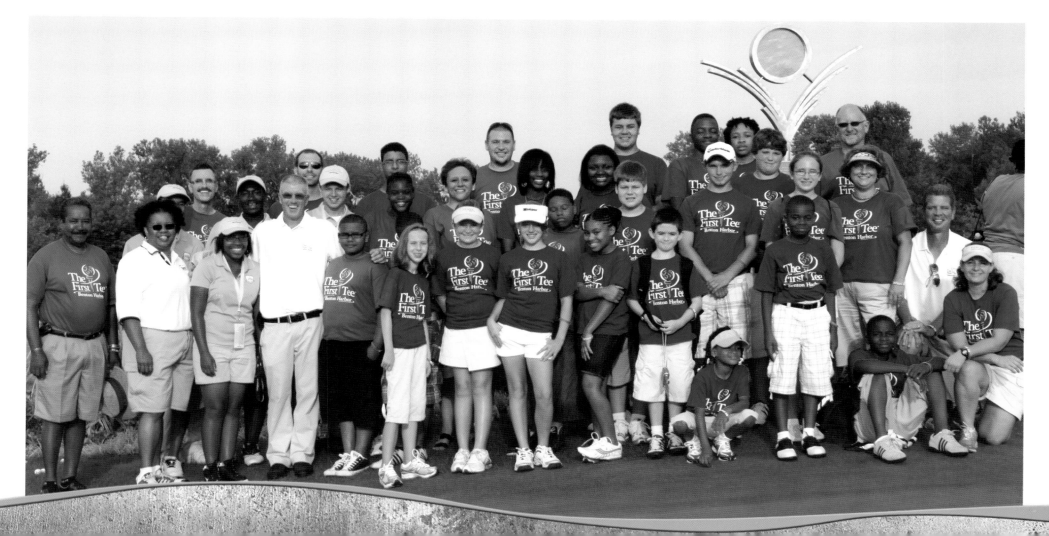

*A*fter completing the eighteen tee markers and the Day Lily ("Hole 19"), Jerry and Josh thought their collaboration was at an end. "But wait, there's more."

Harbor Shores officials decided to commission two more sculptures to commemorate Nicklaus' two Amateur titles. Generous sponsors dedicated one to Jerry, and one to Josh. The artists had a completely free hand to design the sculptures that would honor them. "It was amazing to have such freedom," marvels Jerry.

Jerry chose a lattice structure, with a variety of floral elements that pop through and intertwine. "I wanted to combine glass styles and structures from the original eighteen markers," recalls Jerry. "In a way, I was summing up months of work and thought. Think of it as a free association glass collage."

Andres created a "transition piece" synthesizing the tee markers' nature motif with the game of golf. "None of the other markers relate directly to golf, which is the whole reason for the course," he remarks. "The flag, the putter and the golf ball are the only references to the game in any of the sculptures." Josh asked Jerry to weave a vine of vivid, "fairway green" leaves up to the flag, representing the blend of nature and sport. "I love how the leaves pop out against the grass on the course."

1961 U.S. Amateur
Pebble Beach Golf Links

The genesis of Jack Nicklaus' love affair with the seside layout of Pebble Beach Golf Links can be traced to the 1961 U.S. Amateur Championship. Nicklaus dominated the field on one of the world's greatest venues, winning his final match with six holes left to play. Nicklaus was a combined 20 under par with a 112th holes he played to win his second national title.

1959 U.S. Amateur
Broadmoor Golf Club

Jack Nicklaus' domination on golf's grandest stage - the major championships - began at age 19 in the 1959 U.S. Amateur Championship at Broadmoor Golf Club in Colorado. With perhaps the first of countless memorable shots in the majors, Nicklaus hit a 9-iron to eight feet on the 18th hole for a birdie and a 1-up victory over defending champion Charles Coe for the first of his 20 major championships.

History of Water Street Glassworks

Hinkley Renovations Water Street Glasswork's Back Story

by Kathy Catania, Co-founder

"There is something going on in downtown Benton Harbor," my brother-in-law Robert Catania told us in the fall of 1996. "Go check it out." And so we did.

Jerry and I grew up in the area but had been away for many years. What we discovered was unrecognizable. After 40 years of decline, entire city blocks had been demolished. Old curtains flapped out the open windows of abandoned second story offices and apartments. It was heartbreaking to see a city we both loved in such a blighted state.

Near the corner of Territorial and Water Street was the former Turner Furniture building. Above one of the doors perched a steel cutout sculpture. We surmised we had found a clue to the "something going on." We could see the possibilities for the revitalization of the city in this solitary work of art. To us, it was a harbinger of development and a sign that someone cared -- a promise of creativity and rebirth. We were excited and hopeful. This "something" just might breathe life back into the soul of Benton Harbor.

We met Bob Weber and Judy Jones, who had returned to their hometown to renovate the Turner

Building for a restaurant called Art's Café – the first new business to open in downtown Benton Harbor in decades. Bob's enthusiasm for the city was contagious. He acted as tour guide of neighboring buildings purchased a decade earlier by speculators. They had come just a little too early to spark the turnaround of the city. Yet, if not for those very early risk-takers, Benton Harbor would have lost four significant historic buildings: The Citadel, The Hinkley, The New Moon and The Benton Hotel. (All of them, I am pleased to say, are now renovated and thriving.)

I distinctly remember standing at the intersection of Water and Territorial when Bob Weber pointed to the Hinkley Building and said, "If you get say, eight people together to put up $500 apiece, you could have that building." A building for $4,000? At first we thought he was joking. Then, we arranged for a tour.

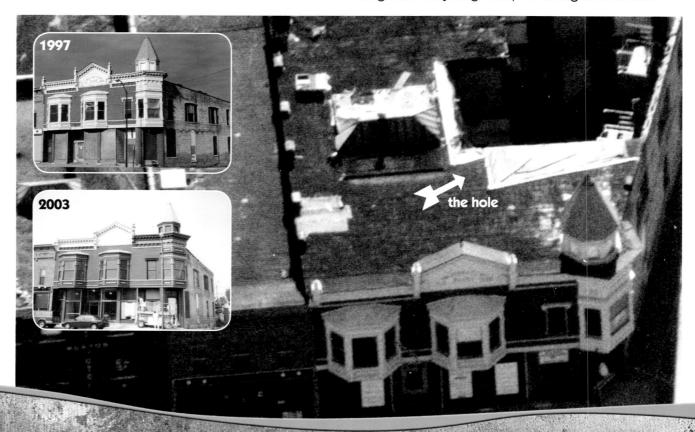

1997

2003

the hole

What we found was a beautiful 19th century building in a woeful state of decay. Built in 1898, the Hinckley was condemned in the 1980s when structural failure caused a quarter of the building to cave in. The roof and two floors had "pancaked" into the basement, leaving a mountain of debris surrounded by the exterior walls.

The building had been exposed to the elements for at least a decade. Three quarters of it still stood. But a broken skylight in the "intact" portion had done almost as much damage as the collapse. Each rain washed down through the entire building. With winter approaching, we decided to wait until spring to take another look before deciding.

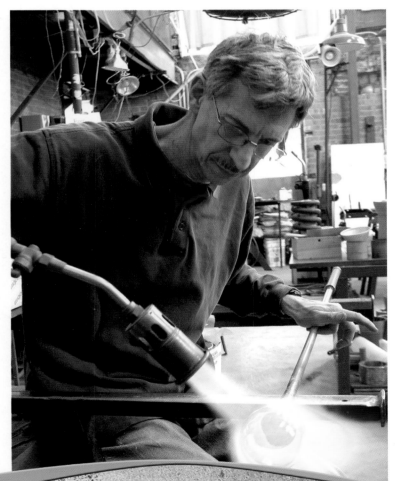

The day of the April 1997 closing, we were allowed in for a "last chance" inspection. We walked into the "better" section to find a huge frozen waterfall, or rather, an icy stalactite, running from the skylight down to the first floor. We shivered at the cold it gave off, making the entire building feel like a freezer. At the closing we joked about what month the ice would melt – June, July or August?! And so we became the third investors in the redevelopment of a unique area now known as the Benton Harbor Arts District.

Cornerstone Alliance awarded the Hinkley Building Project a special $15,000 loan through its "Community Renewal Through the Arts" program. If we stayed in the district for five years, we would not have to pay it back. With this money, we paid the demolition company to take down and clear out the collapsed area.

Under Cornerstone's non-profit umbrella, we wrote two capital improvement grants to the Michigan Council for the Arts & Cultural Affairs, and one to HUD to stabilize and renovate the Hinkley. In partnership with Cornerstone Alliance, Charles Yarbrough (the former Mayor of the City of Benton Harbor) and his wife Mamie, and Innocencio & Flynn Design (local architects), we renovated the building over the course of seven years. It helped to be in an Enterprise Zone with low taxes.

We also added our "sweat equity," as did our friends, spending countless hours repairing the roof, removing tons of debris, and finding the strong, solid core within. The restoration work was exhausting, seemingly endless, and more than a little bit dangerous.

The Hinkley's architectural beauty, and our dream to create a public space dedicated to glass arts, kept us going. When

the lower half of the building was ready, we celebrated with "The Goblet Gala," raising capital to build the glass studio. The non-profit school, named Water Street Glassworks, was officially launched in 2004.

A first floor balcony, or "catwalk" overlooks the former collapsed area, now the basement studio. From the catwalk, visitors of all ages can watch the creative glassblowing process, as teen and adult students blow and shape molten glass. Right next door, customers can sample artisan gelato and purchase fine art glass at Water Street GelatoWorks, our for-profit arm, staffed in part by FiredUp! student volunteers.

I am gratified that WSG helped anchor what is now a district-wide arts campus. Instruction and performances in all genres of dance, instrumental music and voice are offered at the Citadel Dance & Music Center. With the "Fire Arts" of Water Street GlassWorks

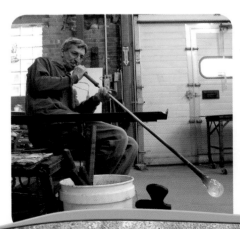

and the Blossom Fehlberg Metal Arts Studio, our vision of an arts district worthy of the name has come to life.

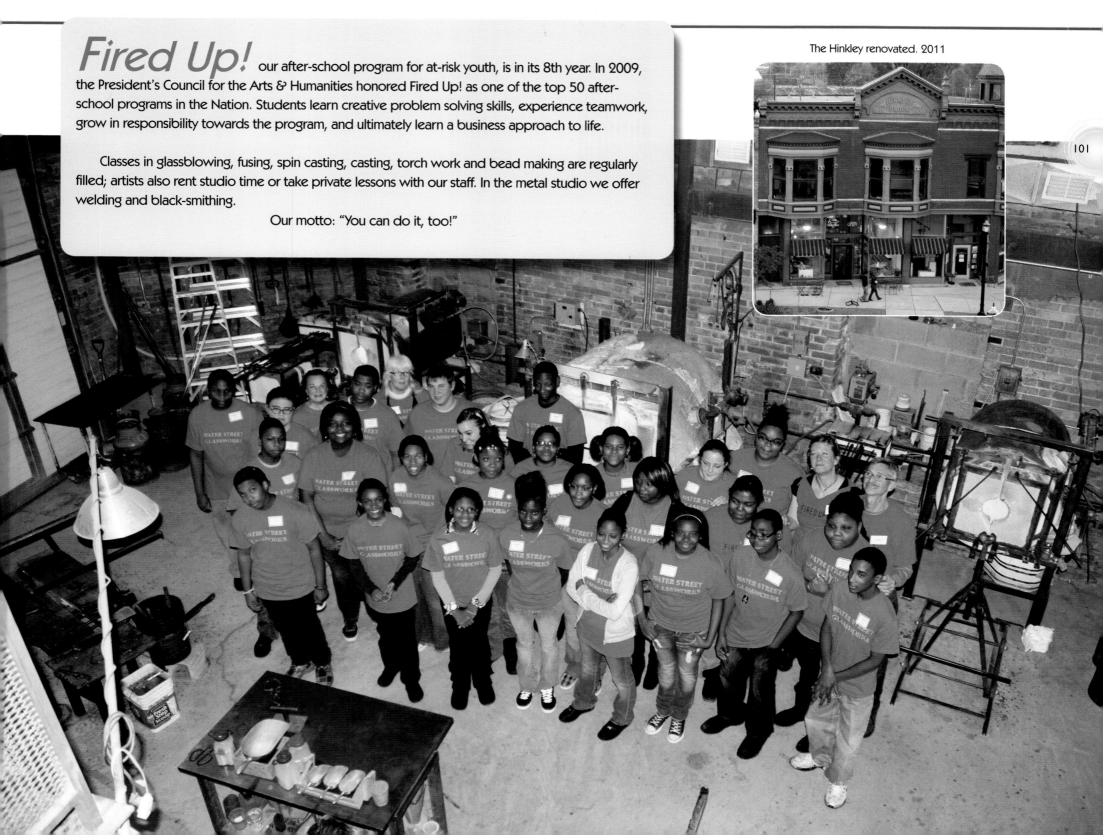

Fired Up!

Fired Up! our after-school program for at-risk youth, is in its 8th year. In 2009, the President's Council for the Arts & Humanities honored Fired Up! as one of the top 50 after-school programs in the Nation. Students learn creative problem solving skills, experience teamwork, grow in responsibility towards the program, and ultimately learn a business approach to life.

Classes in glassblowing, fusing, spin casting, casting, torch work and bead making are regularly filled; artists also rent studio time or take private lessons with our staff. In the metal studio we offer welding and black-smithing.

Our motto: "You can do it, too!"

The Hinkley renovated. 2011

Afterward & Acknowledgements

This book, which in a sense began with a scribbled-on napkin, became a team's labor of love, then a community-wide endeavor. As a "word person," I've come to realize that no words can give the many contributors their full due.

Here are just some of the many people whose generosity of time, and wealth of information, made this book possible. Their contributions, which ranged from hours of interviews, to libraries of images, from anecdotes to historical detail, from big ideas to indispensible tweaks, were a constant and much-needed source of inspiration and joy.

— Greg Ladewski

Don Ames
Josh Andres
Bill Brambilla
Joen Brambilla
Jerry Catania
Kathy Catania
Ron Eng
Mark Hesemann
Sarah Hess
David Knight
Bob McFeeter
Brian Majka
Robin Maxon
Chuck Nelson
Jeff Noel
Anne Odden
Ebon Sanders
Ross Smith
Richard Thomas
Susan Wilczak
Eli Zilke

Finally, special thanks to
the donors who sponsored
the tee markers
listed on earlier pages.